SEVENTIES SPOTTING DAYS AROUND THE SCOTTISH REGION

SEVENTIES SPOTTING DAYS AROUND THE SCOTTISH REGION

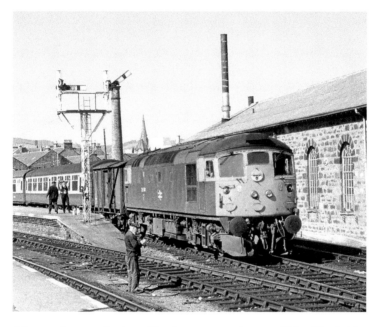

After running past the depot No. 26041 reverses the 07.00 Kyle of Lochalsh–Inverness train back into the platforms at the Highland capital on Saturday 28 May 1977. (Colin Whitbread)

Kevin Derrick

AMBERLEY

This edition first published 2016

Amberley Publishing
The Hill, Stroud
Gloucestershire, GL5 4EP

www.amberley-books.com

Copyright © Kevin Derrick, 2016

The right of Kevin Derrick to be identified as
the Author of this work has been asserted in
accordance with the Copyrights, Designs and
Patents Act 1988.

ISBN 978 1 4456 6081 3 (print)
ISBN 978 1 4456 6082 0 (ebook)

British Library Cataloguing in Publication Data.
A catalogue record for this book is available from
the British Library.

Typesetting by Amberley Publishing.
Printed in the UK.

Contents

Introduction

The Scottish region had a distinct flavour at the beginning of the decade with its own unique locomotive types to attract the spotters from the south to fill many large gaps in their ABCs. Add to this the scenery to be enjoyed on many of the Highland routes in particular, and large numbers would make numerous pilgrimages to locations as remote as Wick and Thurso, which are as far north as one can travel by rail on the mainland.

Aside from passenger traffic there was still a large number of goods services back then, carrying coal, steel, fish, mail and general merchandise, plus cars from the large plant at Linwood, Scotland's only car factory. It was opened on 2 May 1963 by HRH Duke of Edinburgh. The Linwood project had been conceived a long time before this, as the Rootes Group planned to introduce a new revolutionary small car into the British market to compete against the Mini. To do this they had to expand the company's production facilities, which were then concentrated at Coventry. Because of government policy, however, the

Drivers changing cabs by jumping across from SC51781 at Forres on 21 March 1979 in those more carefree days. (Phil Bidwell)

company was required to build any new factories in a development area. Construction of this giant new Scottish plant began in May 1961 and soon transformed the Paisley District. Over 1,800 new homes were built by the local authority and long-term plans in the area included the construction of additional schools, churches, shopping centres and improved rail and road links.

Employment had risen from about 3,000 people to over 8,000 by the beginning of the seventies. From producing 850 completed cars a week in 1963, production had been expanded to about 2,400 cars. From originally manufacturing one single model – the Hillman Imp – Linwood's output then covered many models for home and export markets.

In addition to the panels used in cars built at Linwood, the Scottish plant manufactured over 4,000 sets of body panels for cars assembled in Coventry and overseas from steel produced mostly at the British Steel Corporation's Ravenscraig, Lanarkshire, factory. In the huge unit machine shop, one of the largest and, at the time, most modern in Europe, 3,500 gear boxes and 3,700 rear axles, front suspensions and steering arms were produced each week for the Avenger range. A shuttle service of container trains operated nine times a week from the Linwood factory sidings to Coventry, taking these components south and bringing back engines, gear boxes and other components from the Midlands for Linwood-manufactured cars.

By the close of the decade its future was grim, as it seemed to be for the United Kingdom's economy generally – nothing new there, I hear you say. However in 1981 the workers at Linwood clocked off for the last time after all the success of the previous years; as the eighties went on, coal, steel and fish traffic would dry up as well.

So let's recall a happier time back in the seventies, when we could stand lineside and enjoy a veritable array of motive power, go on shed bashes and be less likely to get arrested than today.

Kevin Derrick
Boat of Garten 2009

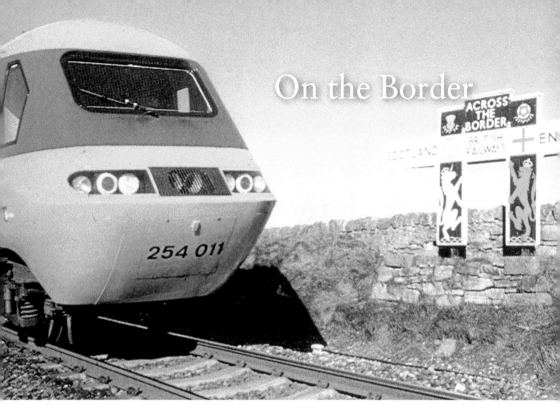

On the Border

Who remembers the 1977 single from Glasgow-born Al Stewart 'On the Border'? By the time of this shot in December 1979, HST sets had all but seen off the Deltics on Anglo-Scottish expresses, relegating them to slower-timed trains. (Strathwood Library Collection)

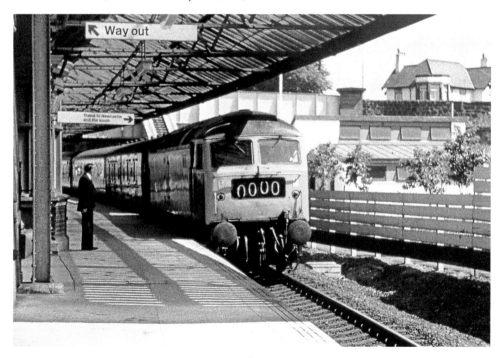

Rolling into Berwick-upon-Tweed on 25 June 1976 was No. 47430; on this day over in the USA, the horror movie *The Omen* was just being released. (Phil Bidwell)

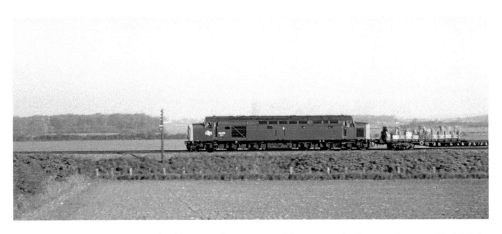

Making steady progress just north of Drem in June 1977 was No. 40078, which spent the second half of the 1970s allocated to York. (Sid Steadman)

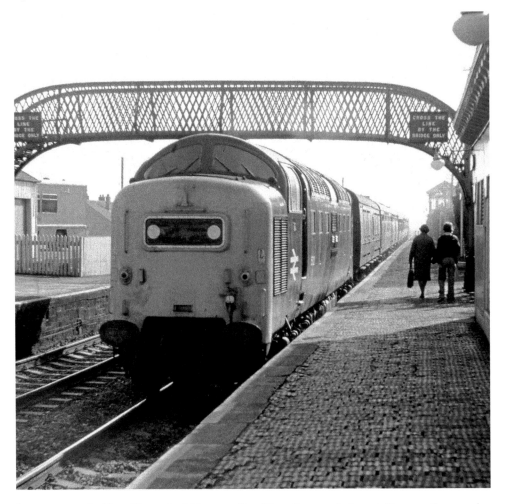

Passengers stand aside as Haymarket's No. 55022 *Royal Scots Grey* speeds through Drem on the same day. (Sid Steadman)

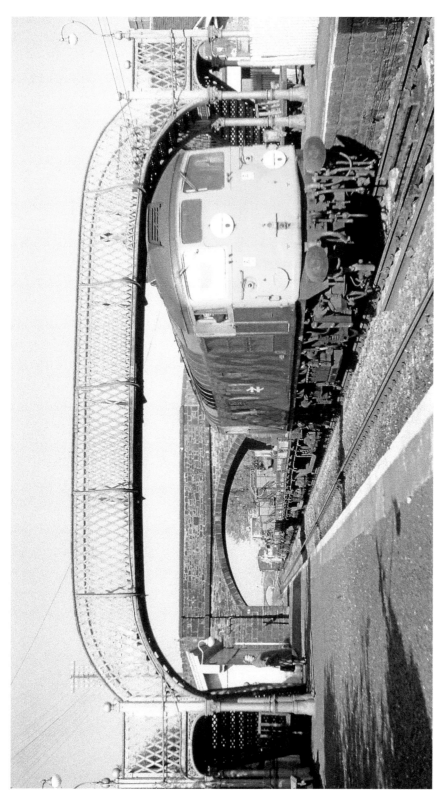

No. 26004, which had been allocated to Haymarket for seventeen years continuously at this point, drifts through Drem with a freight. June 1977 was the month that the Apple II, the world's first 'practical' personal computer, went on sale. Within a decade the industry had conquered the world and would continue to grow. The Class 26 would find an afterlife after Haymarket had finished with it in November 1992 at the Bo'ness & Kinneil Railway. (Sid Steadman)

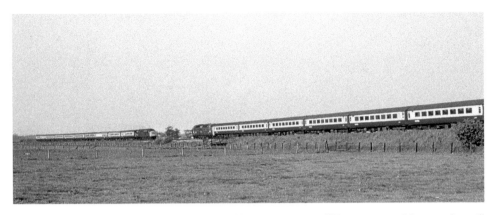

Looking like they are about to crash near Drem are No. 55012 *Crepello* and No. 40159 on 29 May 1978; they will of course pass each other by without harm. (Sid Steadman)

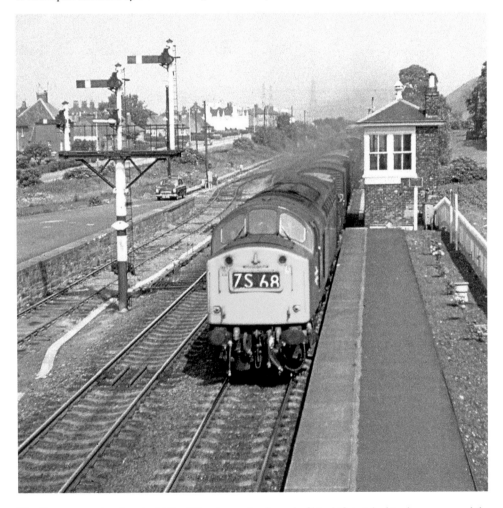

The Prestonpans signalman's old Ford Popular awaits the end of his shift to take him home; meanwhile, No. 40154 accelerates hard with its freight working, most likely with a Deltic following hard behind with a passenger working, on 20 June 1974. (Strathwood Library Collection)

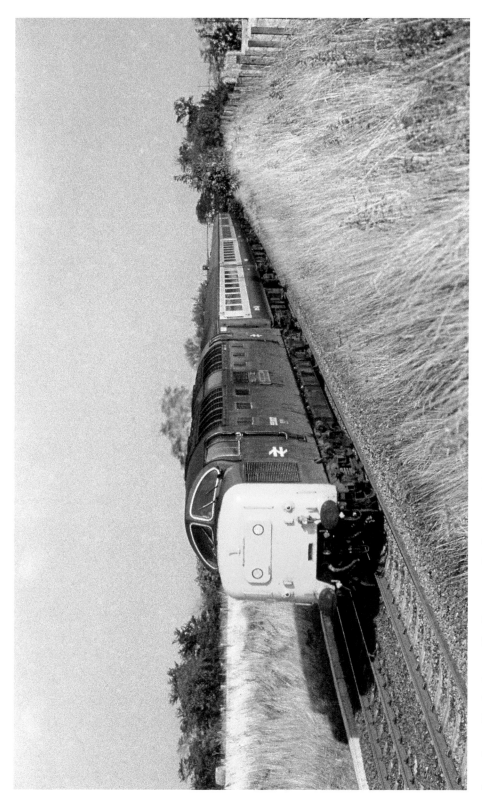

Just such a working hurtles past East Linton on 8 October 1977 with No. 55002 *The King's Own Yorkshire Light Infantry* at the helm. (Late Pete Walton/Sid Steadman)

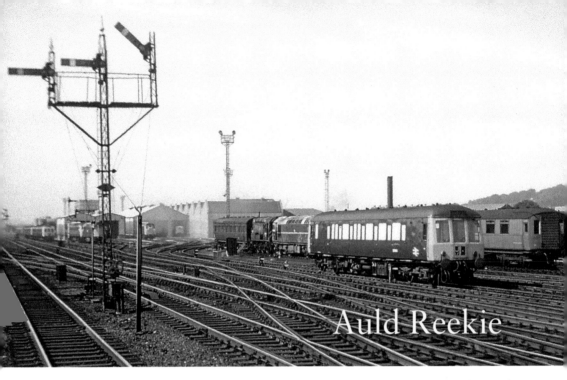

Hanging out of the carriage window as we pass Haymarket in August 1972. SC55013 has had its windows blanked out for departmental use. (Phil Bidwell)

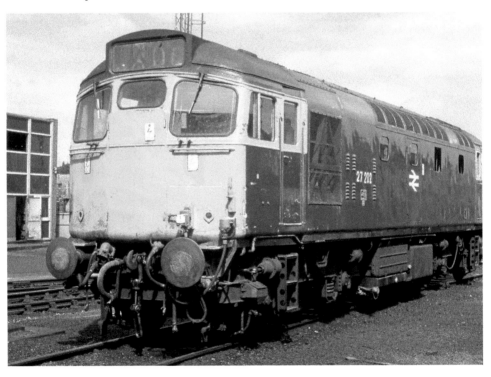

Adapted for use in pairs on the Edinburgh–Glasgow services was No. 27202, standing at Haymarket on 24 July 1977. Edinburgh's nickname 'Auld Reekie' was because of the palls of smoke that hung over it in the days when the city's buildings were all heated by coal and wood. Fire damage would send off this Class 27 in 1980 as the class suffered years of very hard running between the two Scottish cities. (Aldo Delicata)

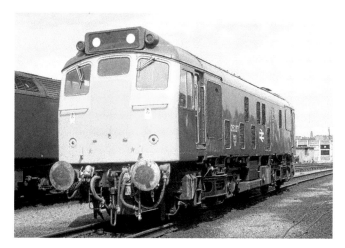

Haymarket was also home at the time to No. 25237, pictured on 24 July 1977. (Aldo Delicata)

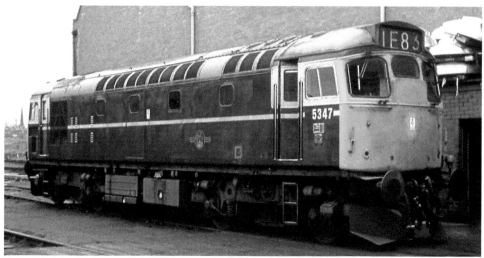

This Class 27 was the first built of her class, becoming D5347 in June 1961. Ten years later she stands at Haymarket. (Grahame Wareham)

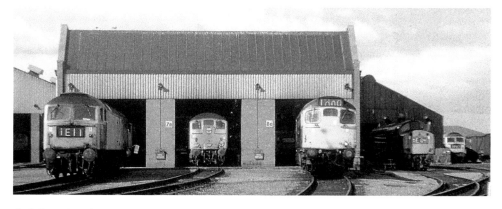

Coded as 64B in August 1972, Haymarket offers a selection of motive power to the shed basher. (Phil Bidwell)

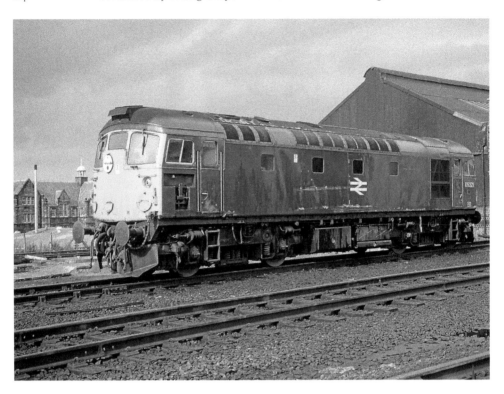

Another visit on 12 September 1970 yielded tablet-catcher-fitted D5321. (Frank Hornby)

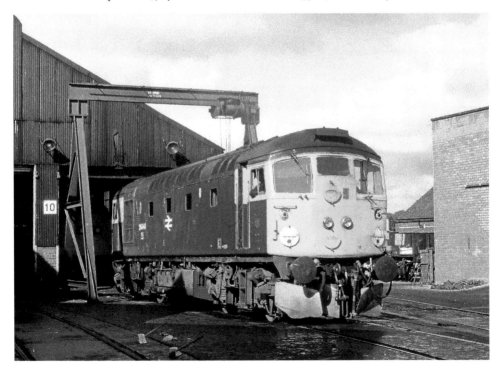

Twin headlights had been fitted to No. 26046, which is visiting from Inverness in 1978. (Tony Shaw)

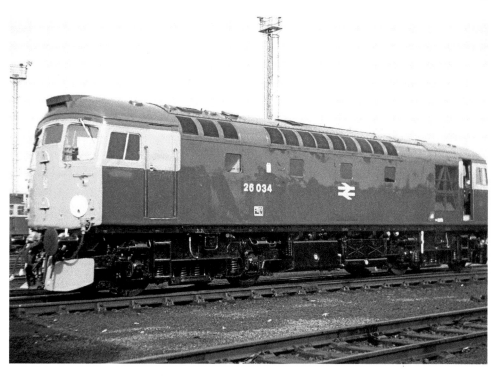

Fresh from Glasgow Works on 27 March 1976 was Inverness's No. 26034 outside Haymarket. (Strathwood Library Collection)

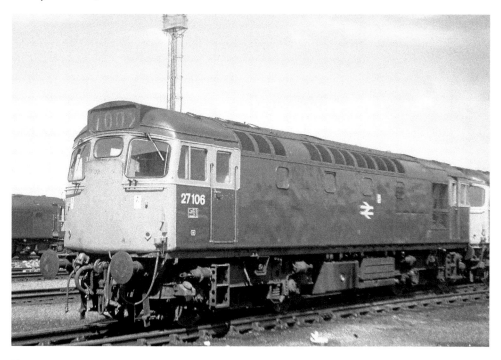

The former 5394 from Eastfield had only been renumbered as No. 27106 the previous month when seen outside at HA, as Haymarket had now become coded, on 26 May 1974. (Strathwood Library Collection)

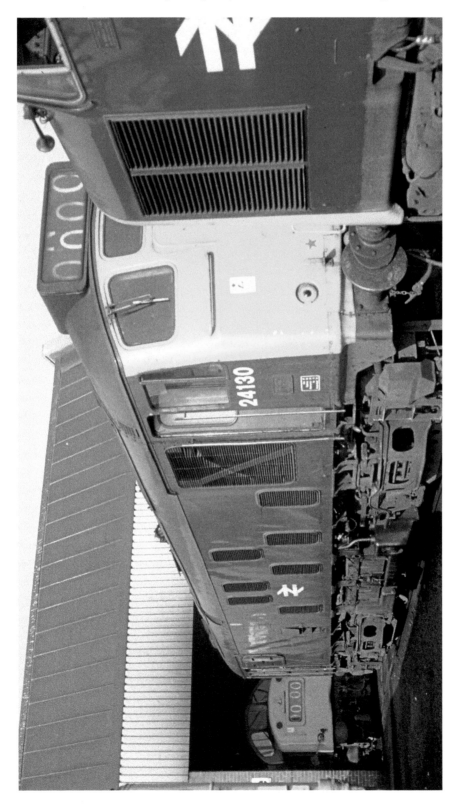

Seen just a few weeks before it went into storage at Haymarket was No. 24130 on 18 August 1976, hemmed in between a Deltic and a Class 40. Stored for six months at Millerhill from January 1977, the Class 24 then headed south along the East Coast Main Line to Doncaster Works, who set about cutting it up by that September. (Strathwood Library Collection)

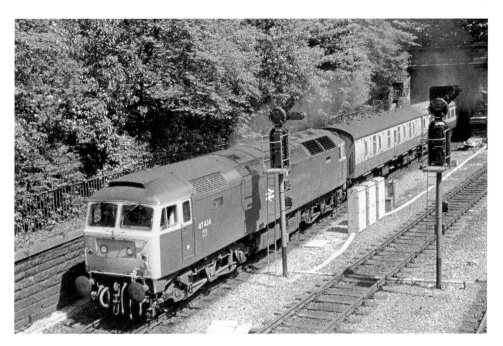

Seen from Princes Street Gardens, the driver of No. 47434 has opened up his charge on 14 June 1977. (Colin Whitbread)

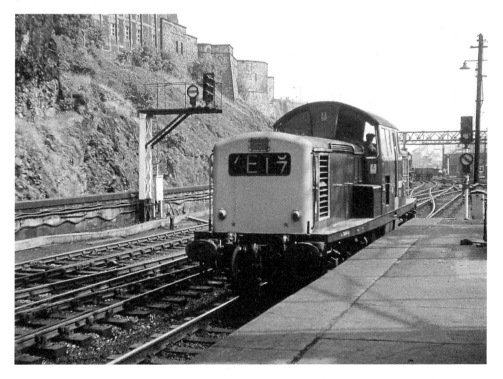

Making a foray into Edinburgh Waverley early in 1970 was Haymarket's D8608. Withdrawn in October 1971, this Clayton lingered around Polmadie until August 1975, when it was sent to the J. McWilliams yard at Shettleston in the Glasgow suburbs for scrapping. (Arthur Wilson)

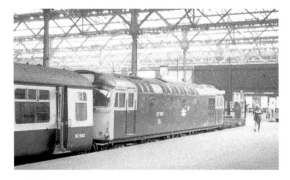

Standing at one of the terminal roads within Edinburgh Waverley on 17 October 1978 was No. 27101 (Nev Sloper)

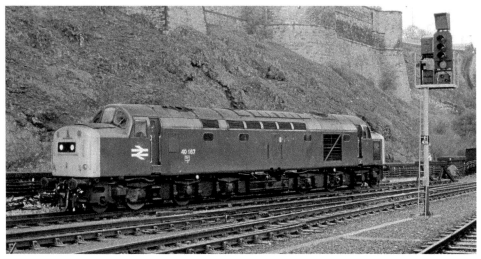

Just over a year later on 21 December 1979, No. 40167 waits outside at Waverley. (Colin Whitbread)

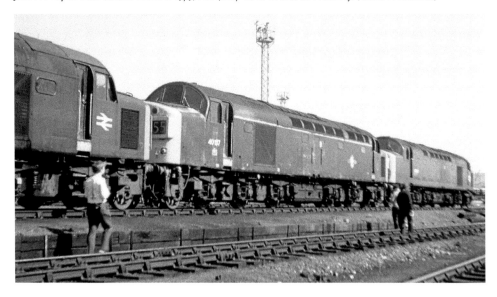

Two blue Class 40s sandwich the green-liveried No. 40137 at Millerhill on 26 May 1974 during a society visit. (Strathwood Library Collection)

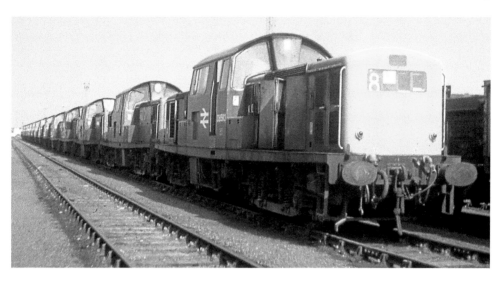

Visits to Millerhill and Haymarket in the early 1970s would be punctuated with long lines of withdrawn, redundant Claytons such as this one, headed by D8583, at Millerhill. (Grahame Wareham)

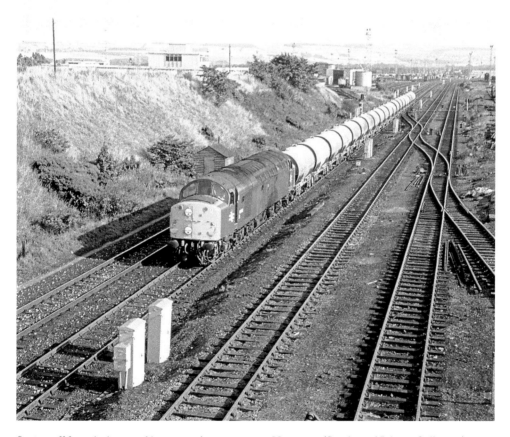

Setting off from the busy yard here on 19 August 1976 was No. 40095. (Strathwood Library Collection)

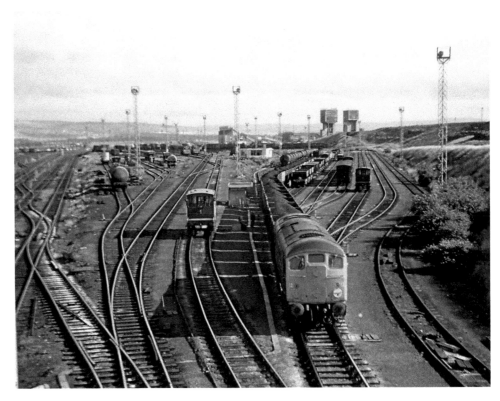

A coal working keeps No. 24069 employed at Millerhill on 29 July 1974. (Phil Bidwell)

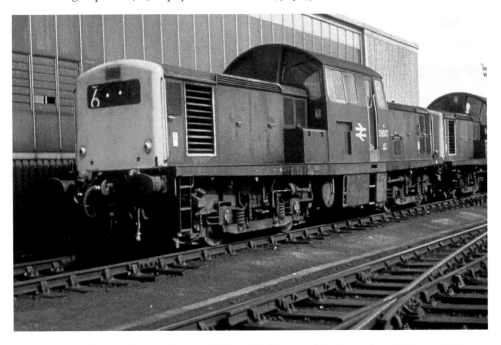

Enjoying a second lease of life was D8507 at Millerhill in July 1970; it had been first withdrawn in October 1968. (Grahame Wareham)

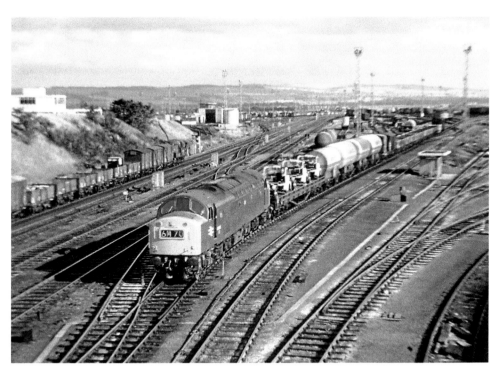

An 08 shunter brings a trip into Millerhill as No. 40190 departs on 29 July 1974. (Phil Bidwell)

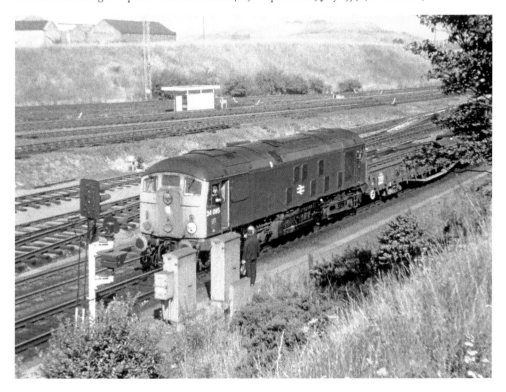

The following week on 5 August 1974 No. 24095 waits to get away as drivers exchange a few words. (Phil Bidwell)

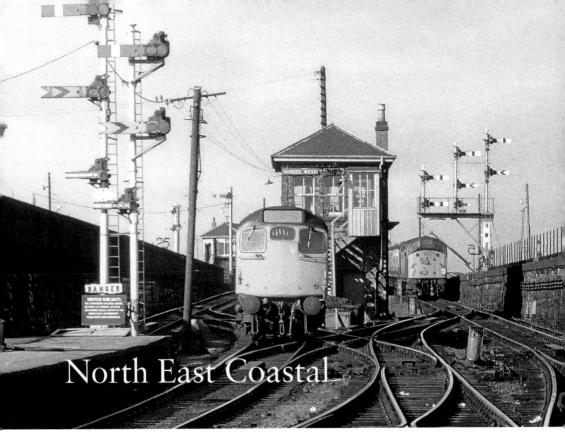

North East Coastal

Activity at Dundee in August 1978 for Nos 27020 and 40057. (Tony Shaw)

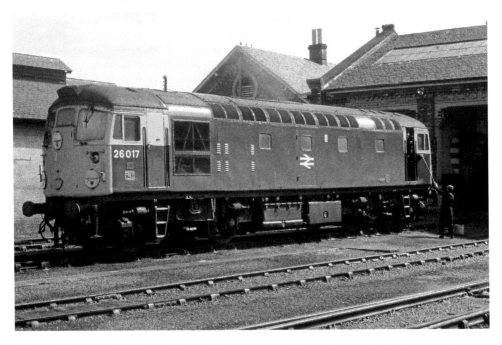

Cleaning No. 26017 the hard way at Dundee West depot on 27 July 1977. It would cost him dearly a few years later but, on this day, John Lennon was granted a Green Card for permanent residence in the United States. Sadly he would be assassinated in New York by Mark David Chapman on 8 December 1980. (Aldo Delicata)

In August 1972 Class 50 No. 419 could be found on shed at Dundee among the Metropolitan Cammell and Gloucester Carriage & Wagon Co.-built DMUs used for local services. (Phil Bidwell)

A shunter rides shotgun fashion on Class 24 No. 5006 into Dundee to couple on to its train in August 1972. (Phil Bidwell)

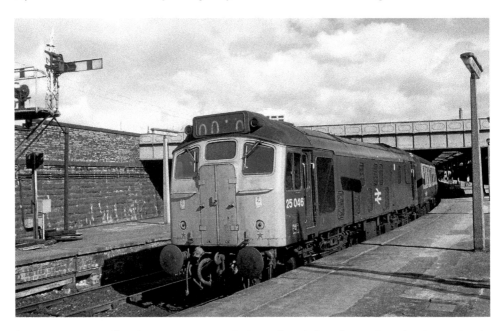

Seen in the station at Dundee in 1978 No. 25046 had moved north from Springs Branch to Haymarket the previous summer. (Tony Shaw)

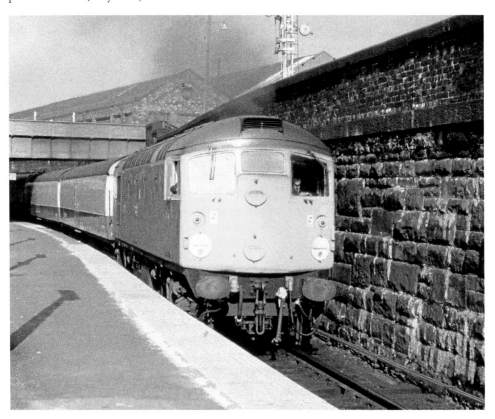

Getting the Postal away from Dundee was No. 26013 on 15 June 1978. (Nev Sloper)

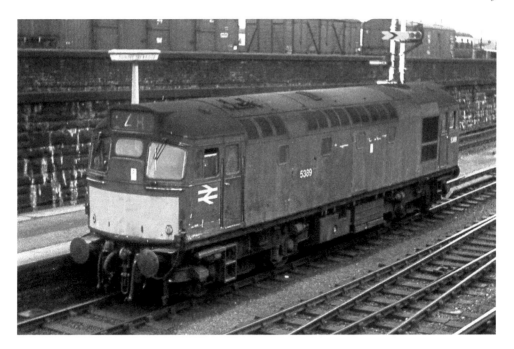

One of the very first locomotives painted into blue was No. 5389, seen in Dundee and needing a repaint by July 1970. (Grahame Wareham)

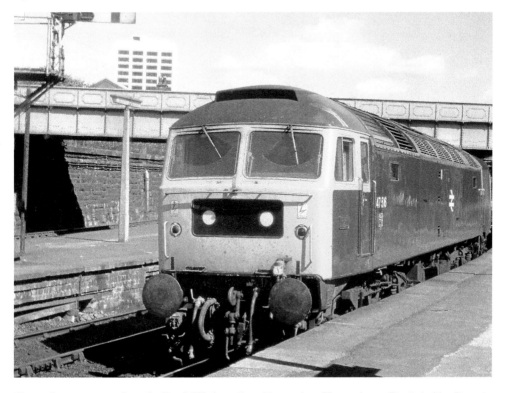

Having been sent new from the Brush Works at Loughborough to Haymarket as D1968 in blue livery in October 1965, it had been renumbered as No. 47516 when seen in 1978 at Dundee. (Tony Shaw)

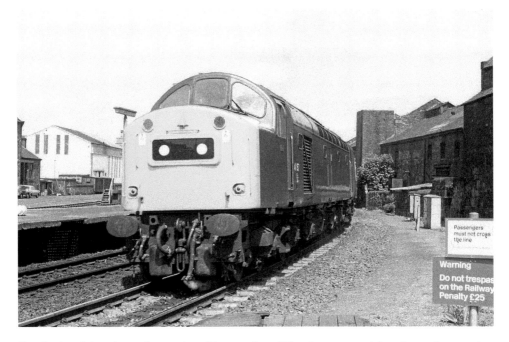

Running into Arbroath on 13 June 1978 was No. 40157. Incredible as it may seem, Arbroath were drawn against Bon Accord in the first round of the Scottish Cup, which was played on 12 September 1885, and they won 36 goals to nil! (Nev Sloper)

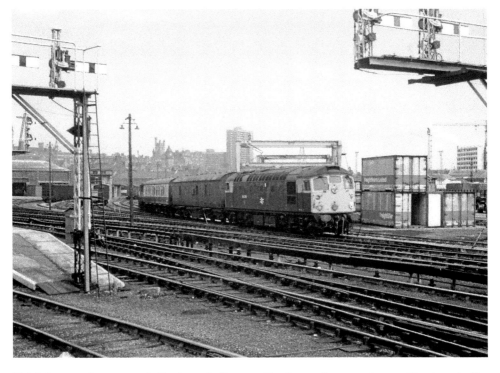

Freightliner containers are stacked in the yard adjacent to Aberdeen station around 1975, as No. 26020 shuffles a few parcels vans around the station for loading. (Les Byatt)

The glory days of Aberdeen Ferryhill and the servicing of Gresley's A4s are long gone by 15 February 1975 as workmen attend to the rather modest lighting from the days of steam. (John Green)

Built by Andrew Barclay at their Kilmarnock Works during 1959 as D2423 was No. 06006, seen on the same day at Ferryhill as above. Aside from the odd works visit to Glasgow or Inverurie in the 1960s, this locomotive would remain in the north east of Scotland for its entire working life in Aberdeen and Inverness. It ended its days cut up at Dundee during 1983. Did you see it? (John Green)

Known locally as 'The Piper', Nos 24104 and 24120 wait at Huntley with the Invergordon to March gas pipes on 11 October 1974. (Dougie Gray)

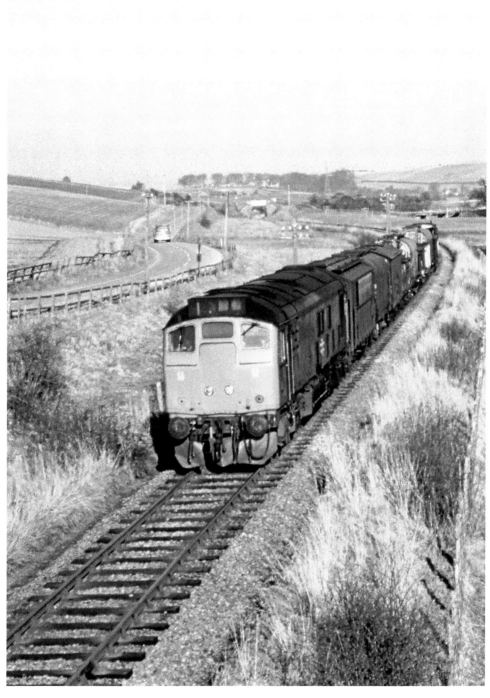

On former Great North of Scotland Railway metals at Keith was Class 24 No. 5116, on 12 March 1973. Across the country Slade were at number one with 'Cum on Feel the Noize'. The following year would see Roller Mania sweep through every girls' school in the land as the Bay City Rollers won the affections of school girls everywhere. (Dougie Gray)

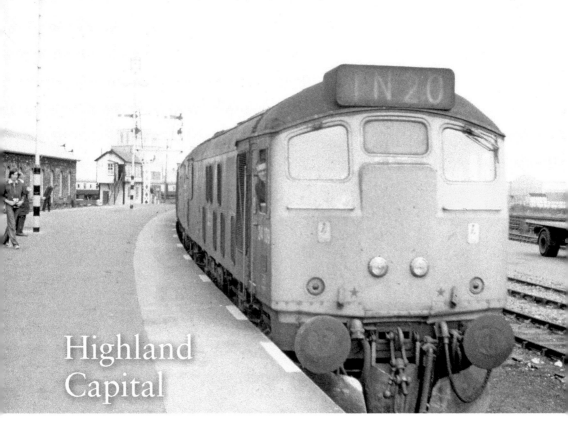

Highland
Capital

One of the biggest albums of 1975 was Elton John's *Captain Fantastic and the Brown Dirt Cowboy*; it was also the year Revlon launched Charlie in the UK and Henry Cooper larked about in the showers with Kevin Keegan and a bottle of Brut. It would be the penultimate year for No. 24129 seen here rolling into Inverness from the south. (Les Byatt)

Situated within the triangle of lines between the station and the Rose Street signal box, Inverness depot held its usual selection of Class 24s and 26s when seen from the Far North platforms in 1973. (John Green)

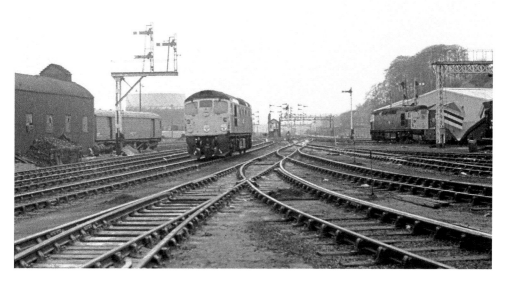

Several rail-mounted snow ploughs are in reserve in case they are needed on 21 March 1975, while No. 26030 awaits its next duties. Steven Spielberg's film *Jaws*, about a giant shark gobbling American surfers, was so gripping that it left British swimmers terrified even of visiting the local municipal pool. (Phil Bidwell)

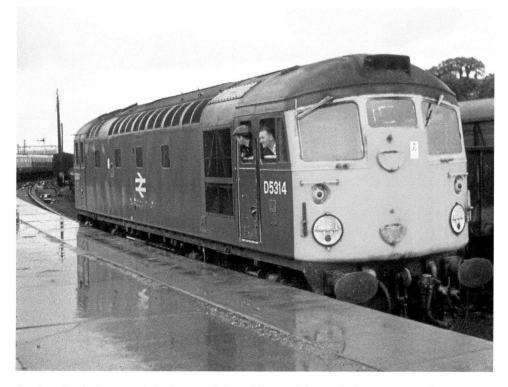

Another rainy day in the north for the crew of Class 26 D5314 in July 1970. In the cinemas was *Carry On up the Jungle* with Sid James as the lead. (Grahame Wareham)

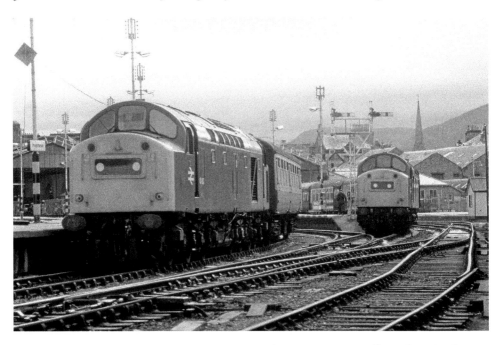

Two trains for the south wait to leave behind Nos 40160 and 40184 on 22 July 1979. (Stuart Broughton)

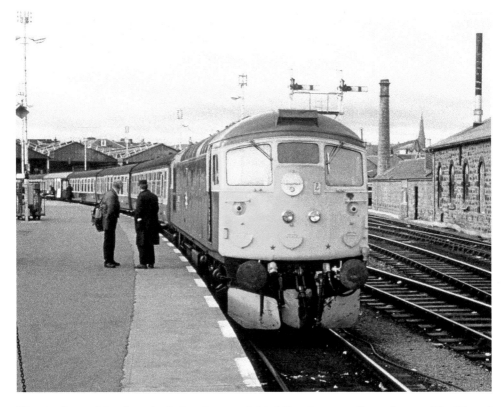

There is plenty of time for a chat before departure behind No. 26035 on 14 September 1977. The Class 26 wears its snow ploughs all year round – a badge of office for an Inverness-based locomotive. (Nev Sloper)

An accident within Inverness depot to D5131 during the summer badly damaged the far cab, seen in this view taken in August 1971. The unfortunate locomotive was cut up early in 1972 within St Rollox Works in Glasgow, with its good cab being saved in case it could help another crash victim. (Grahame Wareham)

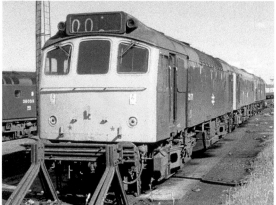

A Sunday line up at the depot includes Nos 25171, 25232 and 26006 on 3 September 1978. (Colin Whitbread)

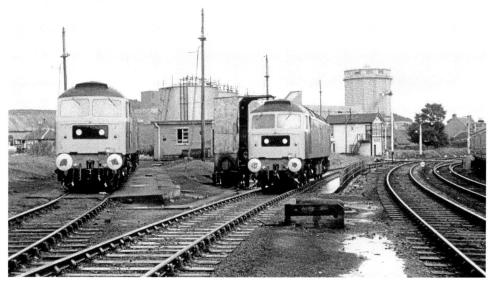

Dresssed up on shed on 14 September 1977 as part of the Queen's Silver Jubilee celebrations were Nos 47469 and 47470. (New Sloper)

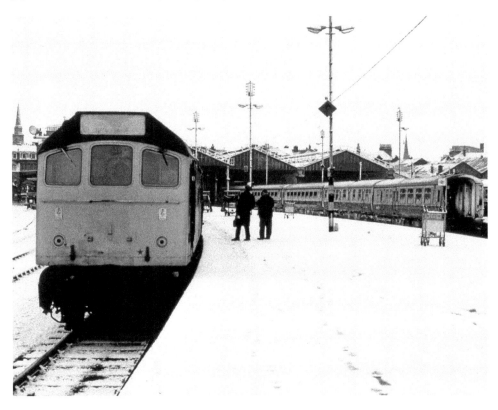

The Highlands are famous for snowfall, but Inverness is often spared the white stuff as it is almost at sea level. However on 21 March 1979 it has settled in this view of No. 25083. (Phil Bidwell)

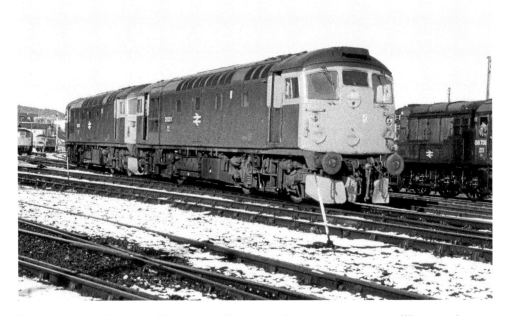

Two days later and the snow still lies about as Nos 26031 and 26022 are seen coming off Inverness depot on 23 March 1979. (Phil Bidwell)

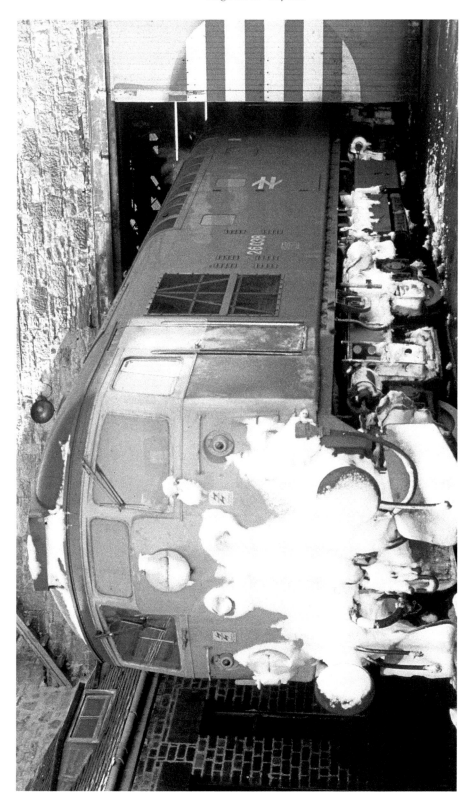

The snow must have been thicker further north or along the Highland main line to the south, as witnessed by No. 26038 standing by the shed building on the same morning. (Phil Bidwell)

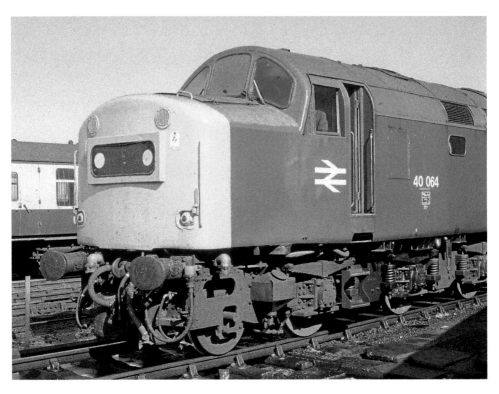

One of Haymarket's Class 40s to be modified with central headcodes and to have its central doors welded up to prevent draughts was No. 40064, arriving on shed on 3 September 1978. (Colin Whitbread)

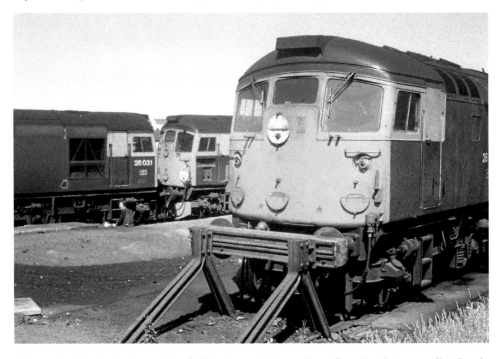

A chance for a breather in the sunshine for Nos 26027 and 26031 and a staff member during 1975. (Les Byatt)

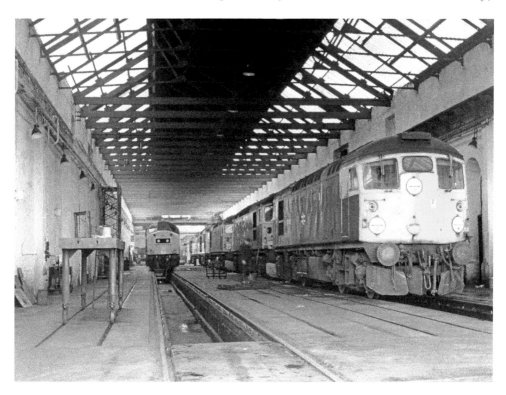

Once part of the Highland Railways Lochgorm Locomotive Works, the diesel depot building at Inverness was well suited for maintenance. No. 26028 is seen here on 20 April 1977. (Nev Sloper)

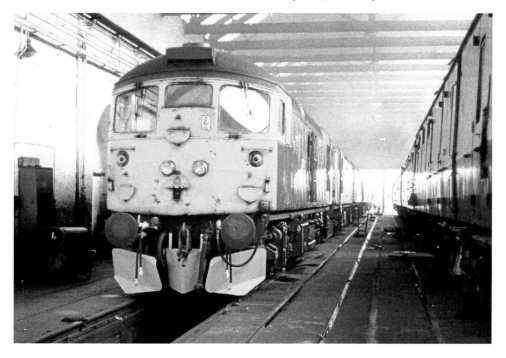

Whereas the line up on 23 March 1979 included Nos 26043, 26040, 26041, 47550 and 20002. (Phil Bidwell)

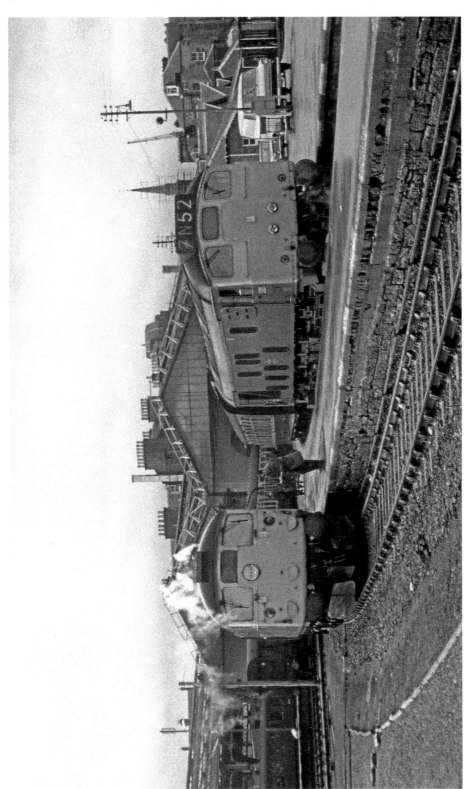

Waiting to get away on 15 September 1970 were Class 24 No. 5121 and Class 26 No. 5336. (Rail Photoprints)

Far North Lines

Heading north onto the Black Isle at Clachnaharry in 1975 was No. 26027. (Les Byatt)

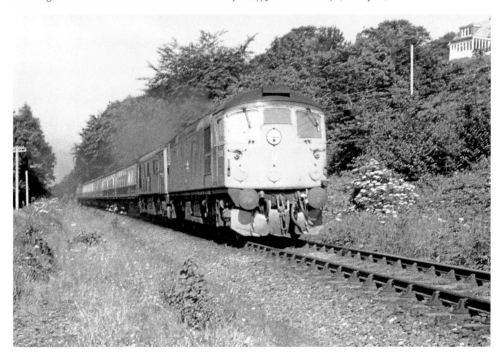

Piloting a Class 24 away from the speed restriction across the Caledonian Canal at Clachnaharry was No. 26045, also in 1975. (Les Byatt)

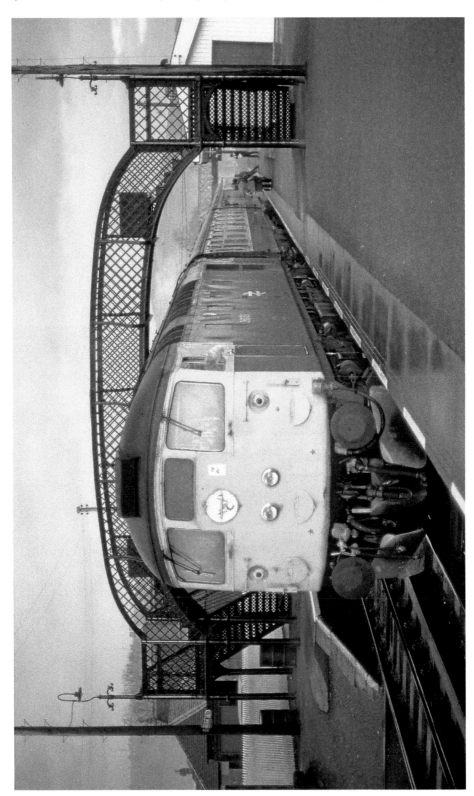

Rainy Highland weather greets passengers at Dingwall who have arrived aboard No. 26039's train on 10 December 1979. (Strathwood Library Collection)

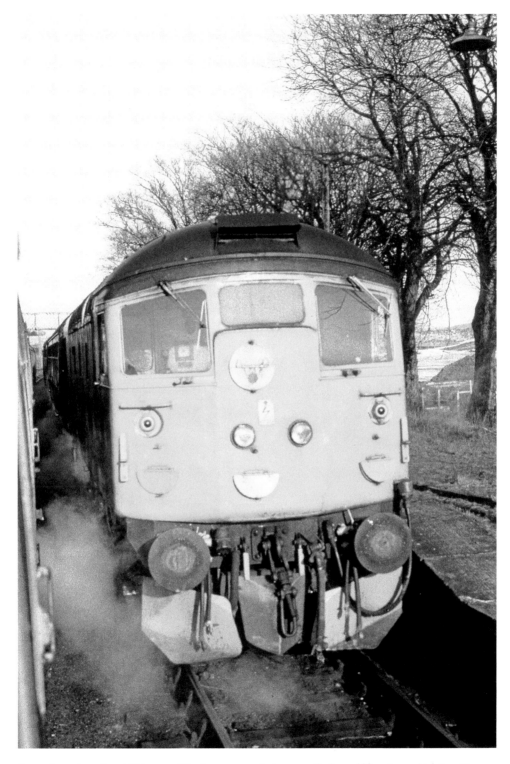

Steam-heated coaches at Tain on 22 March 1979 as our train passes the looped No. 26045, which is waiting for us to clear the single line. (Phil Bidwell)

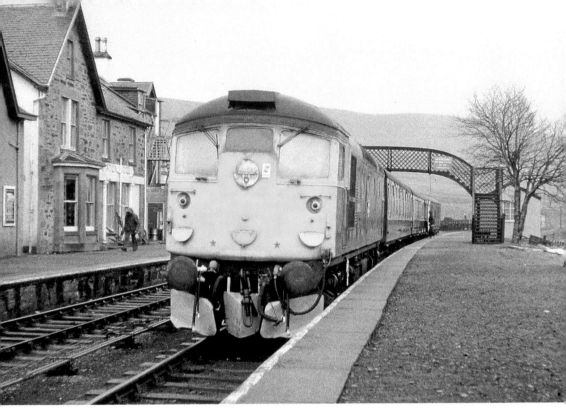

Travellers to and from Kyle of Lochalsh would cross trains at Achnasheen, which offered the chance for enthusiasts on the first train to arrive to gain a few shots for the album such as here on 12 May 1979 while No. 26025 waits for No. 26041 to arrive and clear the section. (Both: Nev Sloper)

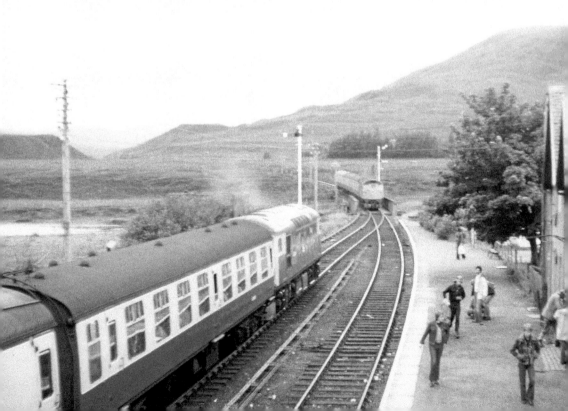

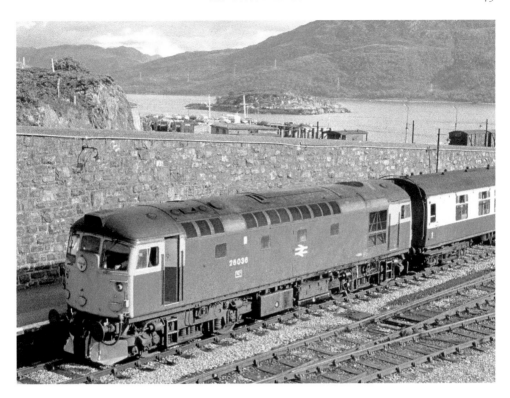

The Isle of Skye can be seen across the water at Kyle of Lochalsh as No. 26036 waits to set off with the 17.52 to Inverness on Monday 4 September 1978. (Colin Whitbread)

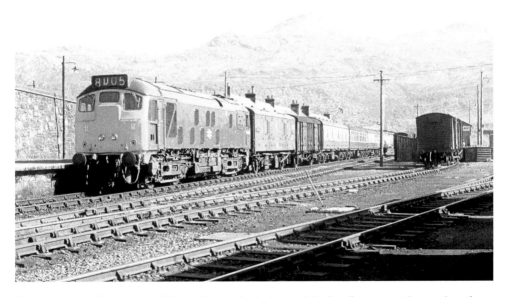

Four years before, No. 24110 would be ready to make the long trek back to Inverness with a number of vans in the train. The television show *Wish You Were Here* went on air for the first time in 1974, making a name for Judith Chalmers who hosted the show until 2003. (Bruce Smetham)

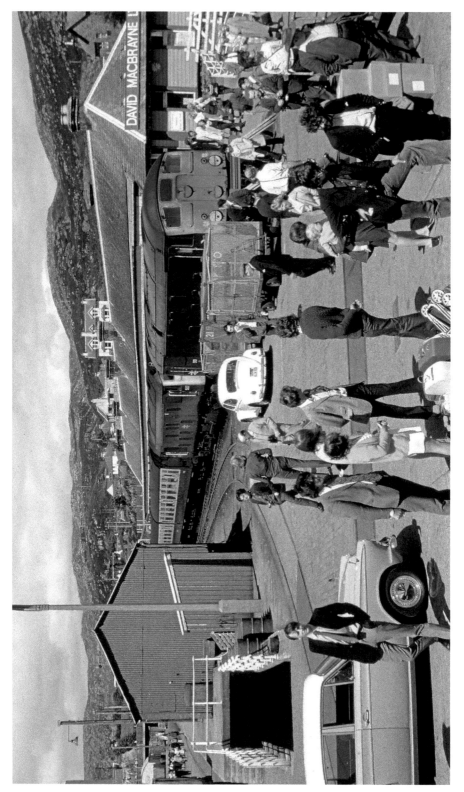

In the days before the road bridge, which opened in 1995, all the traffic to and from the Isle of Skye went across by boat, much of it from Kyle of Lochalsh by MacBrayne's ferries. Seen from onboard one of the ferries, passengers for a Class 24 pairing headed by No. 5113 wait to board in July 1973. (Peter Simmonds)

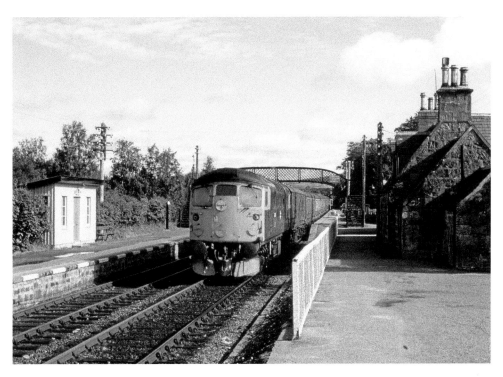

At lonely Lairg station No. 26033 waits with the 11.20 departure for Inverness on 3 September 1978. (Colin Whitbread)

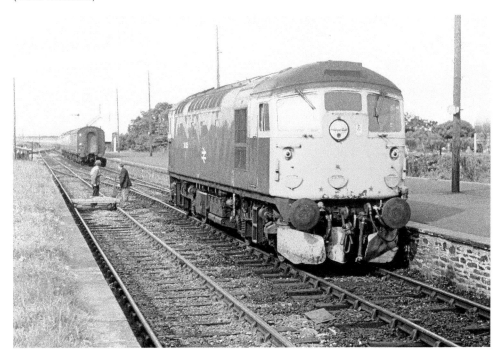

Having set back its stock into the loop on 6 September 1976, No. 26025 can now run round at Wick to head back south. (Phil Bidwell)

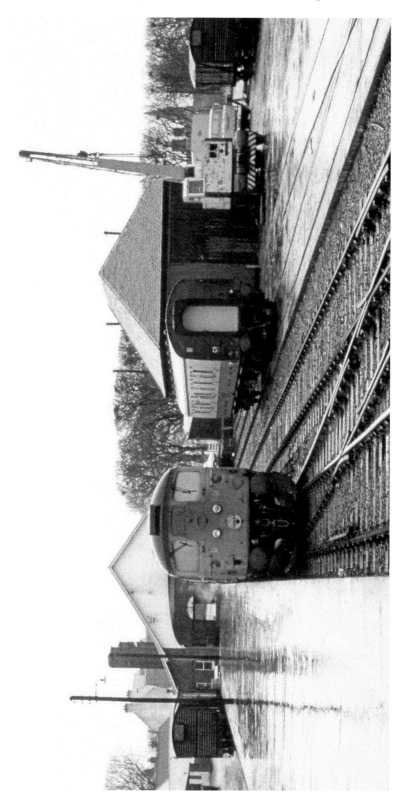

A rain-sodden day at Thurso on 20 April 1977 and 'Knowing Me, Knowing You' by Abba is at dominating the charts as No. 26038 will be our motive power back to Georgemas Junction. (Nev Sloper)

Highland Mainline

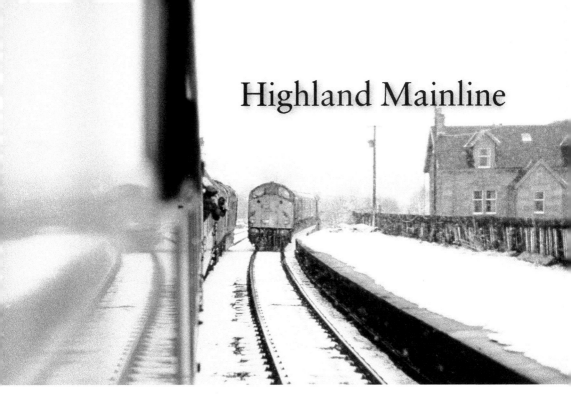

Enthusiasts brave the weather at Tomatin as Nos 26010 and 26025 pass No. 40035 *Apapa* on 20 March 1979. The station had been closed here since 1965 although the spur to the distillery remained open afterwards for the whisky traffic. (Phil Bidwell)

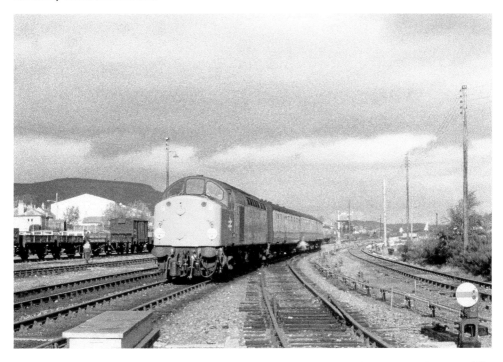

The yards at Aviemore were still open on 20 October 1978 as No. 40111 snaked its way into the station. The Strathspey Railway's dreams of running into Aviemore station still seemed very distant back then as British Rail would not entertain running for the preserved railway into their station until 1998. (Nev Sloper)

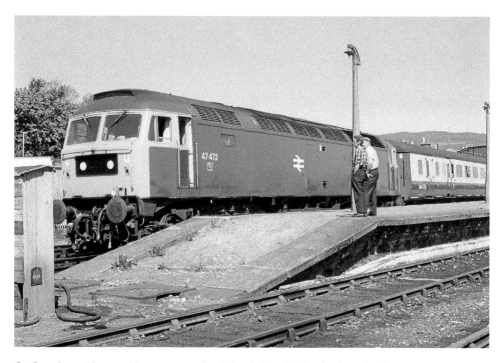

On Saturday 28 May 1977 No. 47472 waits for the single line ahead to be cleared at Aviemore while heading the 10.35 Inverness–Euston service known as 'The Clansman'. (Colin Whitbread)

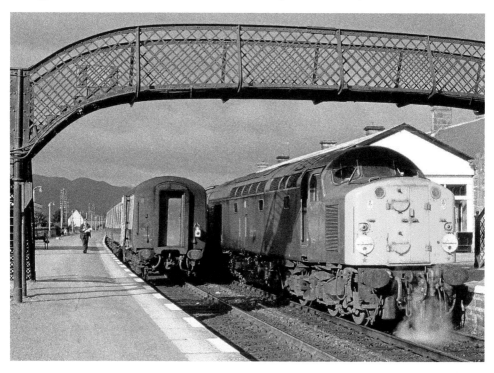

Another chance for trains to pass at Kingussie for No. 40071 in charge of the 22.35 Fridays-only Euston–Inverness in the early morning light of 2 September 1978. (Colin Whitbread)

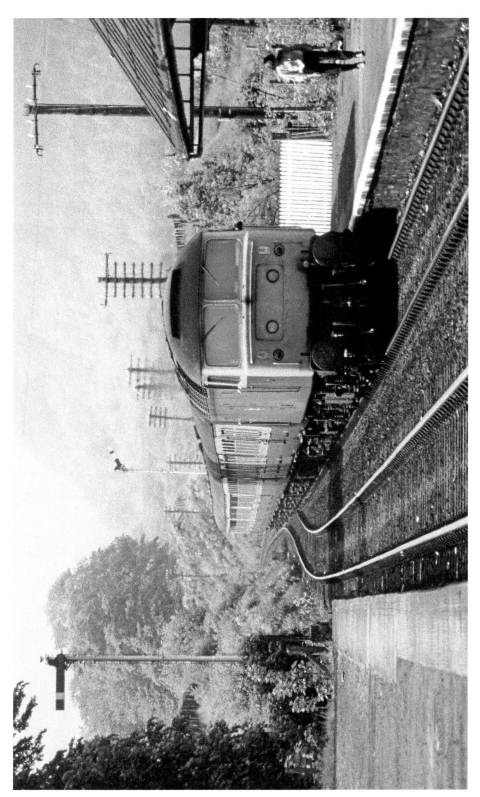

An afternoon Inverness–Edinburgh service arrives behind No. 47546 at Dunkeld in the summer of 1979. (Strathwood Library Collection)

South from Perth

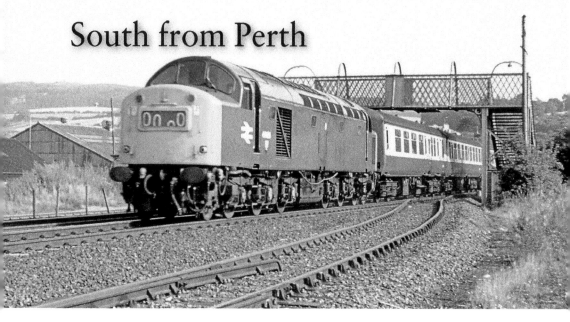

During the hot summer of 1976 No. 40184 is seen near Perth on 18 August. (Strathwood Library Collection)

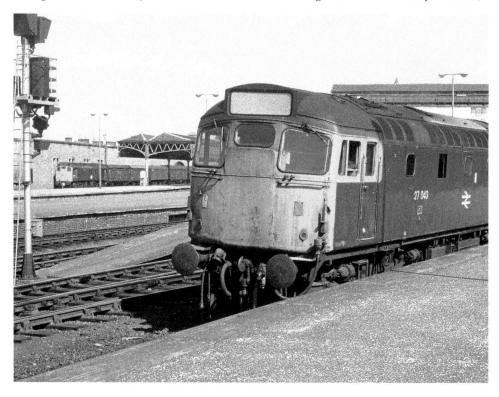

The clatter of Sulzer engines reverberates across Perth station on 13 June 1978 with No. 27043 and a distant Class 25 on parcels vans. This was the year that Ally's Army went to support Scotland in the World Cup hosted by Argentina. A young Diego Maradona would be the emerging star of the tournament as England failed to qualify for their second World Cup in row. (Nev Sloper)

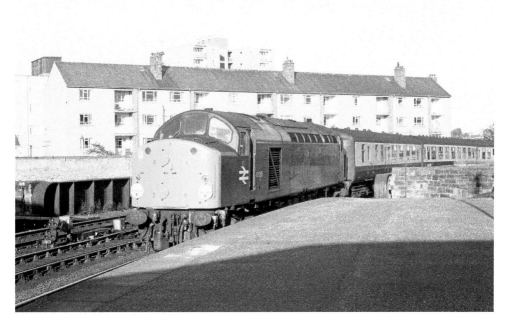

On 18 October 1978 No. 40085 was arriving into Perth from Dundee. (Nev Sloper)

As a sleeper service waits alongside at Perth on 18 November 1972, a Cravens DMU waits to depart for Glasgow. (John Dawson)

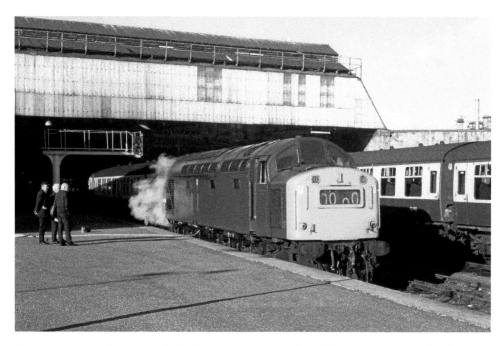

A chance to top up the water tanks feeding the steam heat onboard No. 40060 during the Perth stop on 17 October 1978. (Nev Sloper)

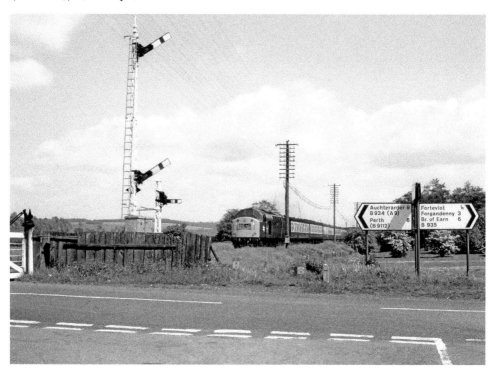

The gates are closed at Forteviot on 27 May 1976 ready for the approaching No. 40184. To the chagrin of England's football fans and the delight of Scotland's, Scotland won the Home Internationals for the first of two years in a row. (Ian Harrison)

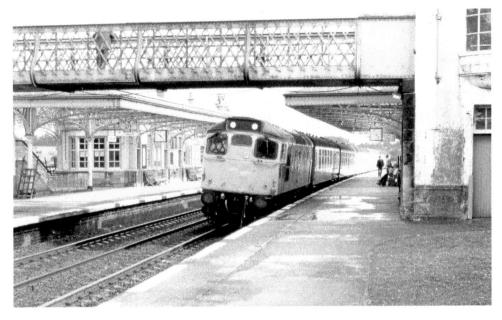

Making the stop at the once very grand Gleneagles station on 14 August 1979 was No. 27104. (Nev Sloper)

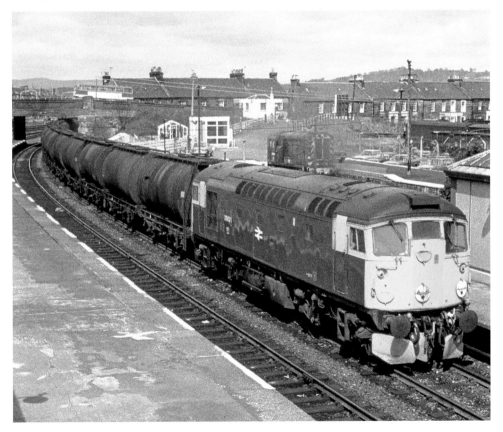

Stirling station still boasted a shunter as a pilot in 1975 when No. 26021 hurried a tank train through. (Arthur Wilson)

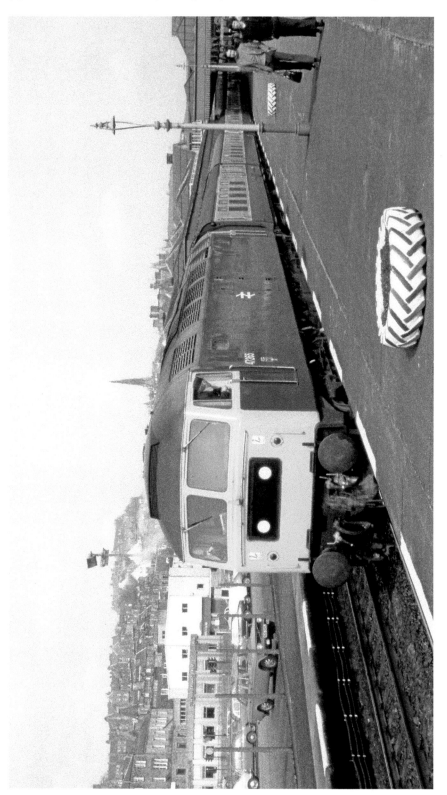

Patriotically decorated tractor tyres act as flower beds for a summer display at Stirling on 11 May 1979 as the driver of Immingham's No. 47265 watches the last passengers off his train. The James Bond film this year was *Moonraker*, which was a story centred around Space Shuttles. Considering the first flight of one had only taken place in October 1977 with the shuttle *Enterprise*, the Bond team were certainly on the ball, as this storyline had no link back to an Ian Fleming one. (Nev Sloper)

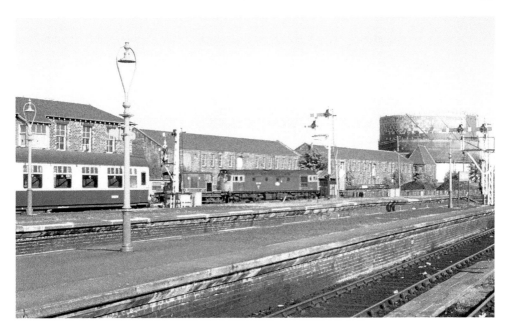

Pictured at Stirling on 13 June 1978, No. 27111 shuffles about the station limits. Nearby Bannockburn was the scene of a fierce battle in 1314 during the Wars of Scottish Independence between the Kingdoms of Scotland and England. (Nev Sloper)

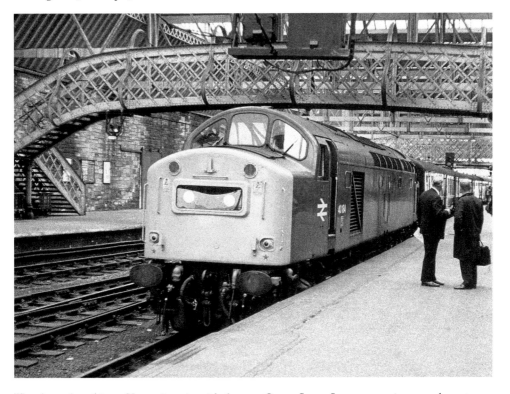

There's much activity as No. 40184 waits with the 13.10 Queen Street–Inverness service on 14 August 1979. (Nev Sloper)

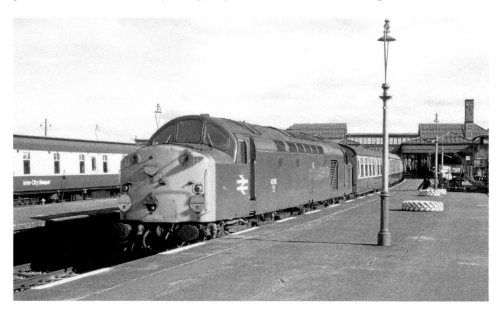

Sleeping car coaches are standing in an adjoining platform at Stirling on 11 May 1979, where No. 40116 has halted with the 16.54 Glasgow Queen Street–Dundee service. (Nev Sloper)

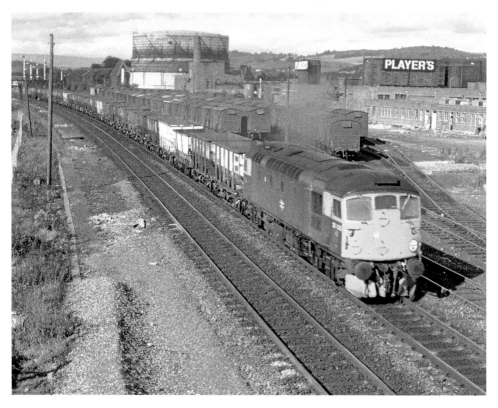

The Player's cigarette factory would later close at Stirling but, when No. 26033 was seen passing in October 1975, it was still generating a lot of traffic for the railway, judging from the vans in the sidings, which would all be sealed once loaded under supervision of the British Transport Police. (Arthur Wilson)

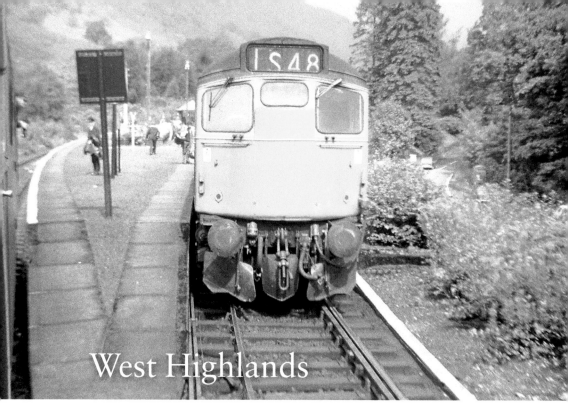

West Highlands

The track from Stirling to Oban had closed in 1965, leaving the line via Helensburgh as the only route for rail travellers. On 6 August 1974 our train for Oban passes No. 27019 at Ardlui waiting for us to clear the section. (Phil Bidwell)

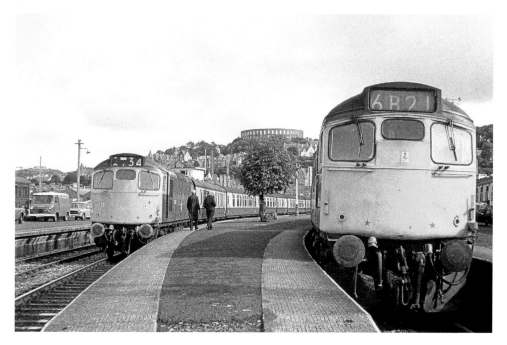

A pair of Class 27s rattle away at Oban during 1974 awaiting departure from the terminus. The station would be later re-sited and much reduced in size. Oban still generates much ferry traffic for the Isle of Mull across the Firth of Lorne. (Len Smith)

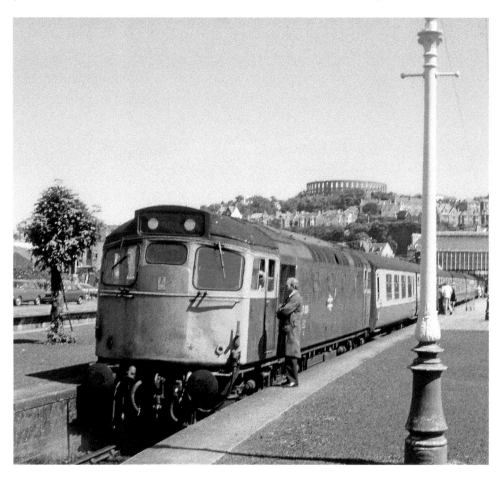

Time for a conversation over last night's television perhaps at Oban on 11 July 1977 as No. 27001 waits with a service for Glasgow Queen Street. Later in the year *The Krypton Factor* debuted on television and that old favourite *Dad's Army* ended its nine-year run on 13 November. (Strathwood Library Collection)

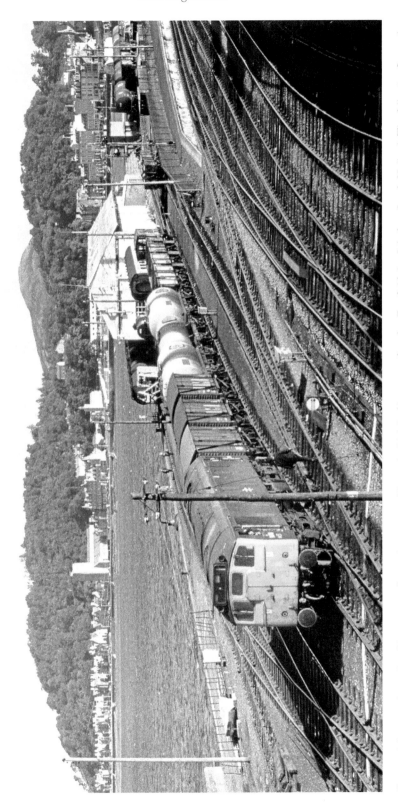

Occupied shunting the yard at Oban on on 4 September 1971 was No. 5176, which had been transferred to Eastfield that July from Leeds Holbeck. The following September it would head back south of the border again to Manchester. (John Dawson)

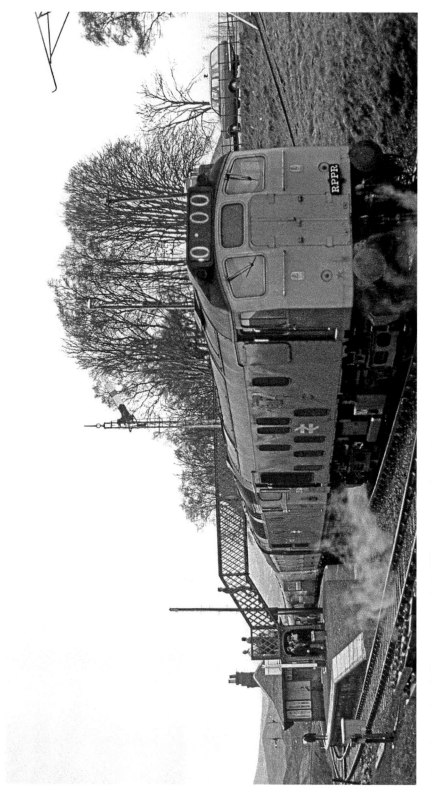

A three-day tour from Paddington starting behind No. 50048, recently named *Dauntless* a fortnight before, headed north to New Street in Birmingham where No. 86253 was put on. The electric brought the train over the border during the night as far as Mossend, where this pairing of Nos 25046 and 27002, seen at Rannoch on 1 April 1978, had come on to take the tour to Mallaig and back. Unfortunately No. 27002 suffered a traction motor fire at MP28¾ (just after Ardlui), resulting in a 32-minute late arrival into Fort William. (Rail Photoprints)

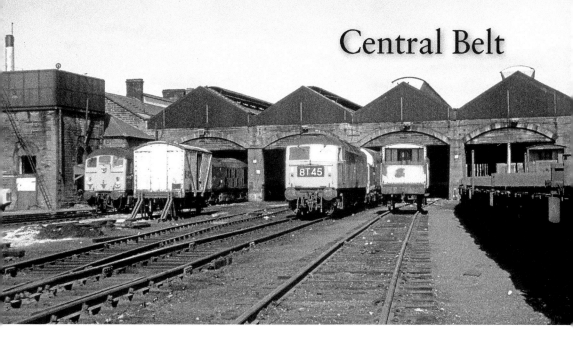

A Class 47 hides a Class 37 and a pair of Class 24s are on shed at Motherwell in 1973. The shed here had been coded 66B when steam ended in 1967 and it became a stabling point from 66A Polmadie. (Strathwood Library Collection)

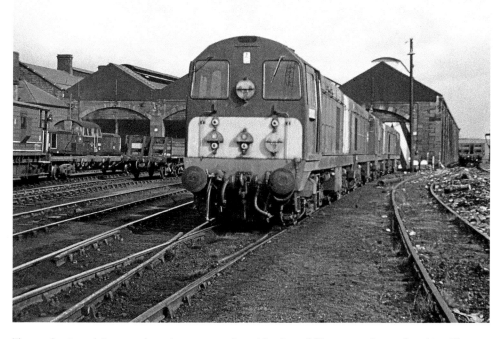

Type 1s dominated the scene here three years earlier with a line of Class 20s and several working Claytons present. The shed would become a depot proper again at the start of 1979. (John Ferneyhaugh)

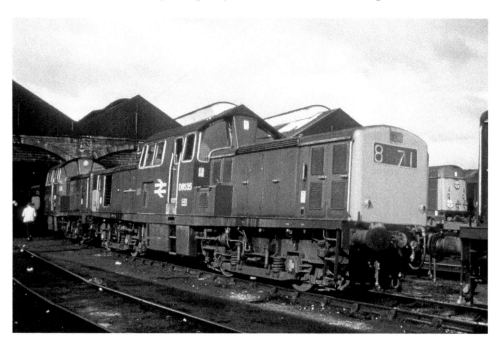

A similar mix was to be seen during another visit to Motherwell the same year, just before D8535 was withdrawn early in 1971 and cut up the following November in Glasgow Works. (Strathwood Library Collection)

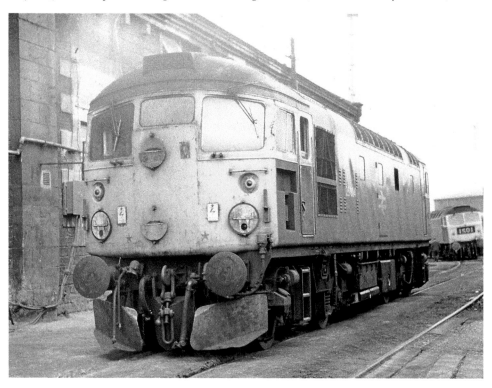

Keeping company with a Class 47 was No. 26024 alonside the sturdily built stone shed building here on 12 July 1975. (Phil Bidwell)

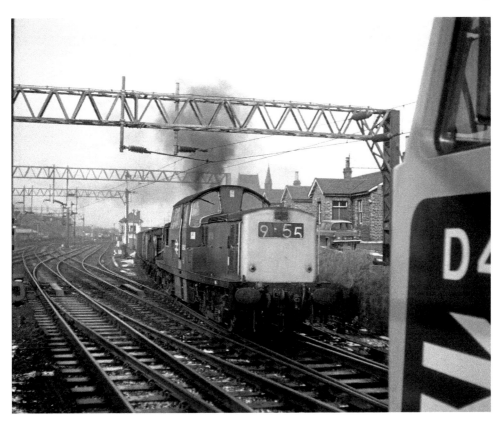

Passing at Motherwell on 12 February 1970 were D8542 with a freight and D442 on an Anglo-Scottish passenger working. (Jim Binnie)

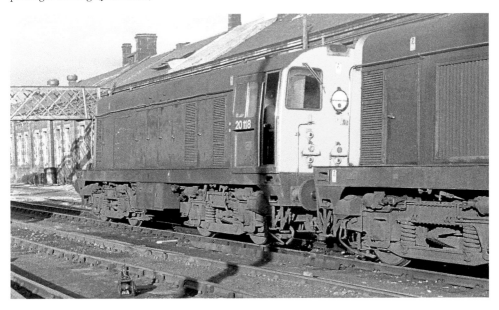

For once stabled away from the usual nose-to-nose position are Nos 20118 and 20108 at Motherwell on 17 March 1975. (Phil Bidwell)

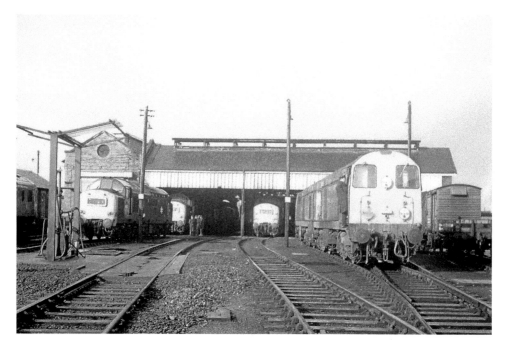

English Electric Classes 37 and 20 outnumber a sole Class 24 tucked away behind the fueling point at Grangemouth on 3 April 1972. A number of coaches from across the country brought over a hundred members of the Dalescroft Railfans Club to Scotland that Easter on a three-day tour, taking in all the depots, major stabling points and Glasgow Works. (Strathwood Library Collection)

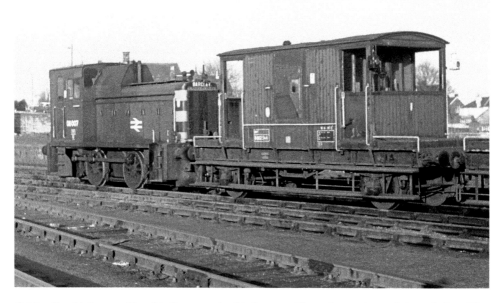

Origianally withdrawn as D2426 in January 1969, this fortunate Class 06 was reinstated six weeks later. This second stint lasted until September 1977, when it was sent to Glasgow Works and cut up during that winter. Renumbered as No. 06007 it found some work in the sidings at Kircaldy on 20 March 1975. (Phil Bidwell)

For the pairs of Class 27s engaged on Edinburgh–Glasgow Queen Street push-and-pull workings, it really would be a central belt as they were thrashed on the tight timings, until the converted Class 47s took over their duties. On 18 October 1978, No. 27205 is the lead engine as this train stops to pick up a healthy load at Falkirk High. (Nev Sloper)

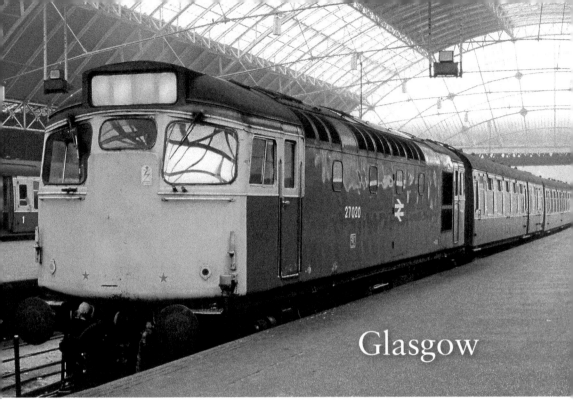

Glasgow

At the buffers on 21 December 1979 was No. 27020, having arrived with the 12.25 Oban–Glasgow Queen Street as dusk decends upon the city. (Colin Whitbread)

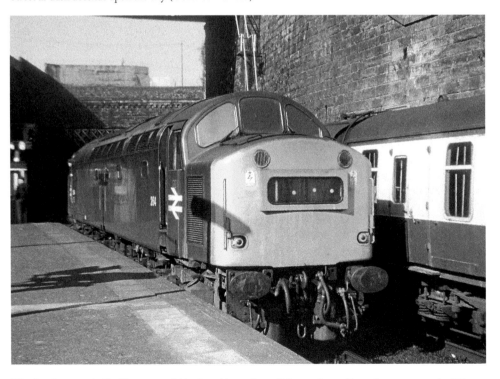

The familiar sound of a Class 40 would be heard bouncing off the cutting walls at the country end of Queen Street in August 1972 as No. 264 fusses about. (Phil Bidwell)

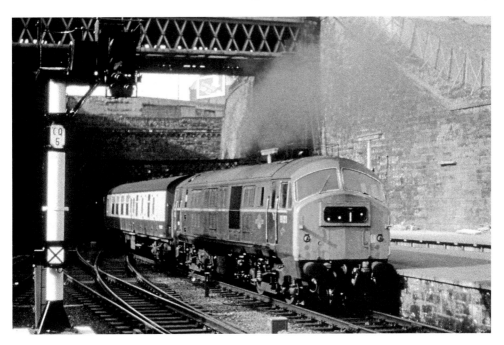

Locally built North British Class 29 No. 6121, now rebuilt with a Paxman engine, gets a good thrash as the banker pushing a train out of Queen Street in June 1970 and up the bank to Cowlairs. (Strathwood Library Collection)

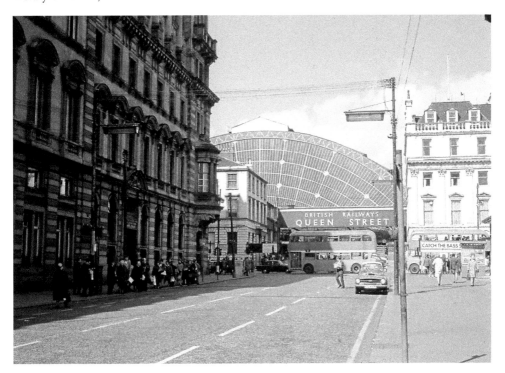

A Triumph TR6 stands parked outside Queen Street on 29 April 1970 as we make our way to Glasgow Central. (Strathwood Library Collection)

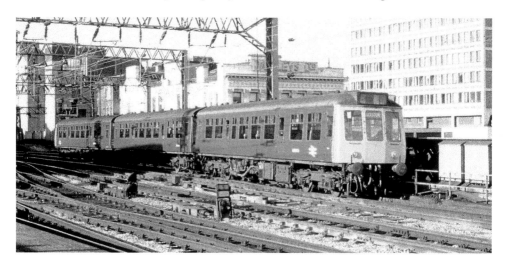

Aside from the famous Blue Trains, a fleet of DMUs would make their way in and out of Glasgow Central throughout the day, as here in 1979. (Albert C Greig)

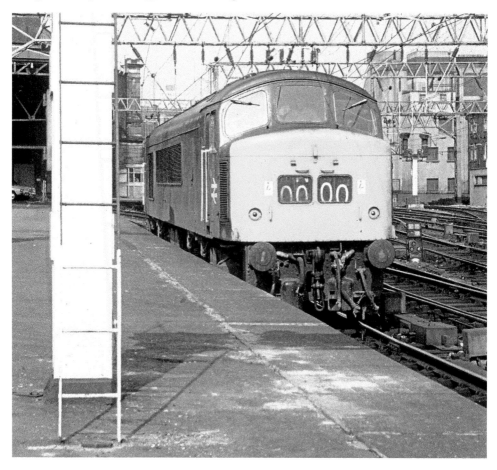

Making its way back out of the station, having arrived from Leeds, on 25 August 1976 was No. 45024. (Strathwood Library Collection)

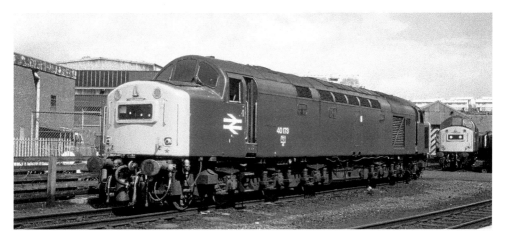

Keeping company with another Class 40 at Eastfield on 29 July 1979 was No. 40173. (Graham Courts)

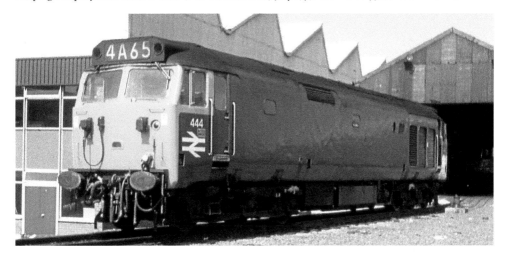

More English Electric Type 4 power at Eastfield with Class 50, No. 444 during August 1971. (Grahame Wareham)

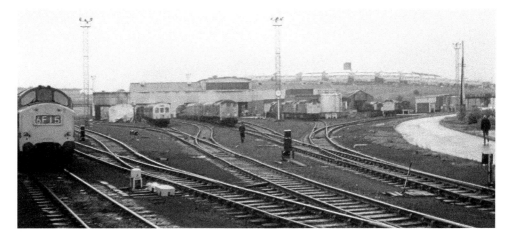

The line up at Eastfield from a passing train as seen in 1975. (Les Byatt)

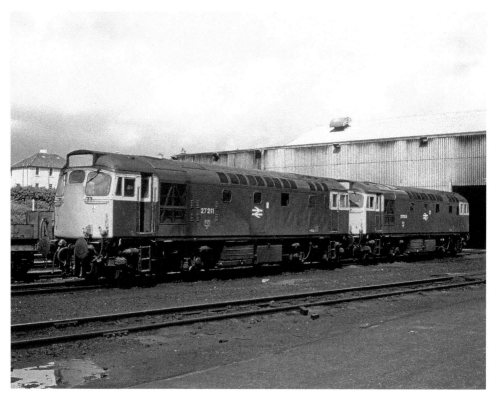

Off duty today are Nos 27211 and 27204 at Eastfield on 29 July 1979 between summer rainstorms. (Graham Courts)

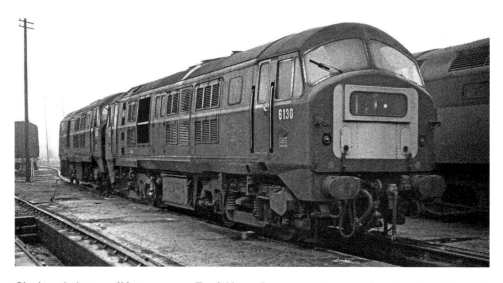

Checking the history of No. 6130, seen at Eastfield on 11 January 1970, it seems to have been stored from 1964 until late 1967, when it was rebuilt as a Class 29, only to be withdrawn four years later. (Rail Photoprints)

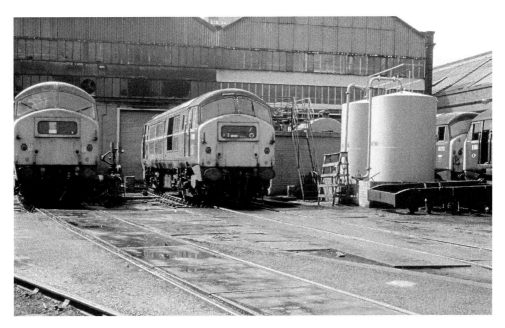

The future for this gaggle of Class 29s, including Nos 6101, 6106 and 6123 at Eastfield in 1970, is not a rosy one either. (Arthur Wilson)

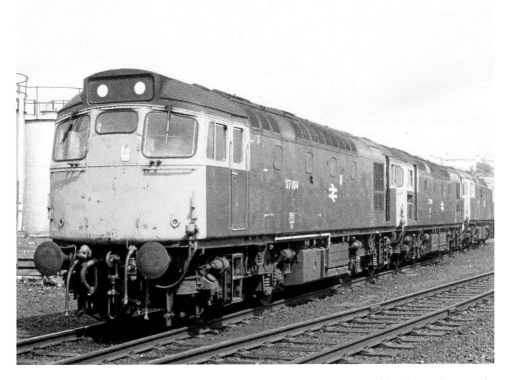

Standing at Eastfield on 24 July 1977 were Nos 27048, 27104, 27014 and 27023. Hot Chocolate took us into the month with 'So You Win Again' and Donna Summer with 'I Feel Love' would take us into August at the top of the charts. (Aldo Delicata)

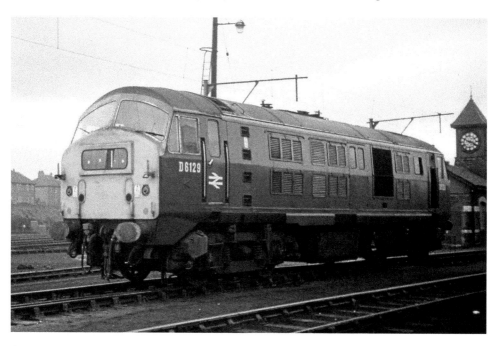

A chance for modellers to check out some detail differences and livery variations among Class 29s, starting with D6129 at Eastfield in 1970. (Len Smith)

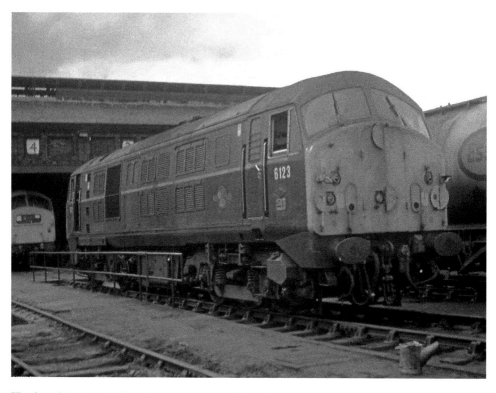

The first of the class rebuilt with a new engine was D6123, but it retained the the original headcode discs and was unique when seen at Eastfield in July 1970. (Grahame Wareham)

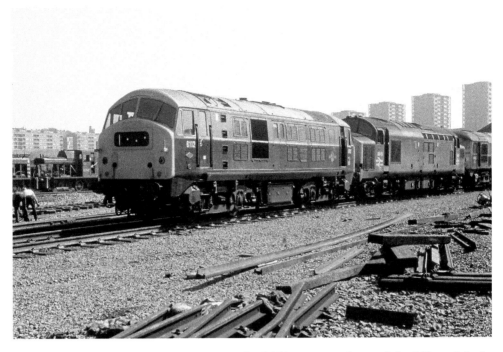

A full yellow nose has been applied to No. 6112 at Eastfield by 1971; note the cannibalised Class 06s in the background. (Arthur Wilson)

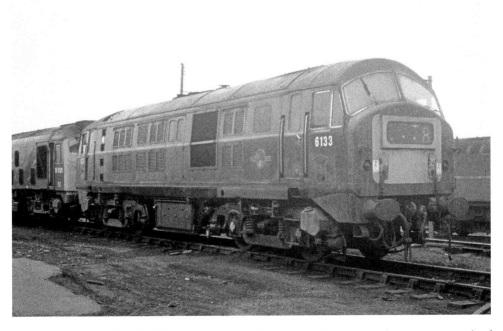

On 30 August 1970 at Eastfield No. 6133 has lost its D prefix but still carries the distinctive sqare style of yellow warning panel. (Strathwood Library Collection)

No spotting trip to Scotland in the earlier seventies could be complete without seeking out the lines of withdrawn Claytons and NBLs such as these selections at Cowlairs. (Photographs: Les Byatt and Arthur Wilson)

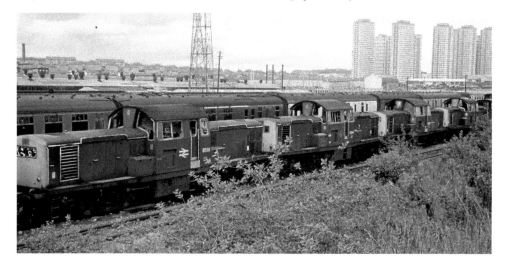

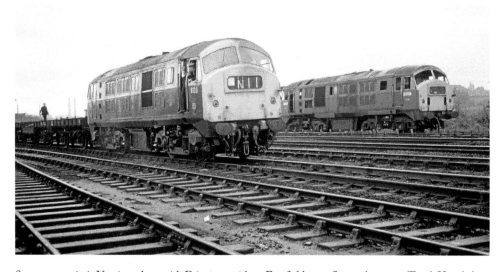

Seen once again is No. 6130 along with D6108 set aside at Eastfield on 13 September 1970. (Frank Hornby)

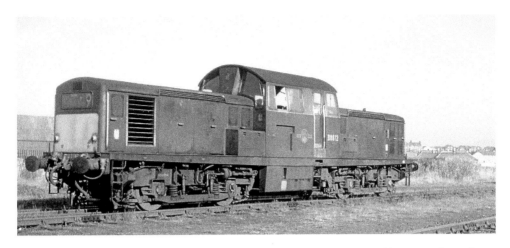

After withdrawal in October 1971, D8612 would be stored at Polamdie and then Glasgow works until 1975, before going to Shettleston for scrapping. (Strathwood Library Collection)

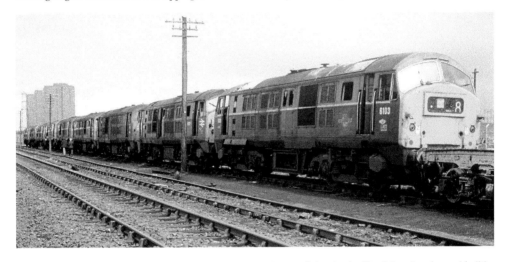

This line up of Nos 6103, 6107, 6113, 6130, 6132, 6114, 6100, 6119, and 6137 in the Cowlairs triangle would all be broken up within Glasgow Works during 1972. (Arthur Wilson)

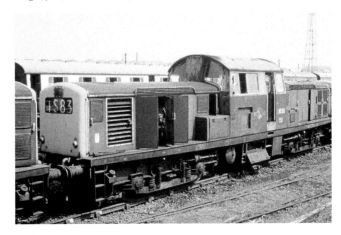

Although stored here for three years D8536 would be taken to Kings of Norwich for scrapping in late 1975. (Strathwood Library Collection)

A tempting line up outside 66A Polmadie in September 1971 and not a single Clayton in sight, as they were most likely tucked away out of traffic off camera. (Arthur Wilson)

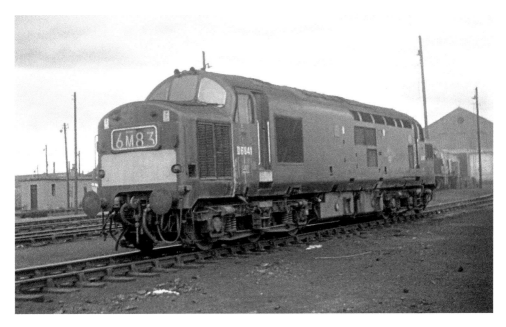

Delivered new in May 1963, D6841 looks like it has yet to receive a full works overhaul when seen at Polmadie in July 1970. (Grahame Wareham)

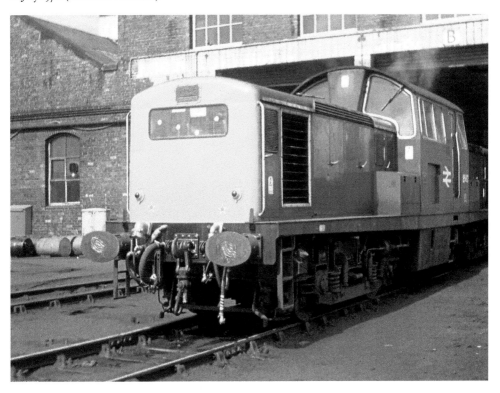

Both engines were ticking over on No. 8567, also on Polmadie the same day. This Clayton, along with D8545 and D8512, went to the GEC works Stafford to act as power supplies during the fuel crisis of early 1972. All three later returned to Scotland during 1972. (Grahame Wareham)

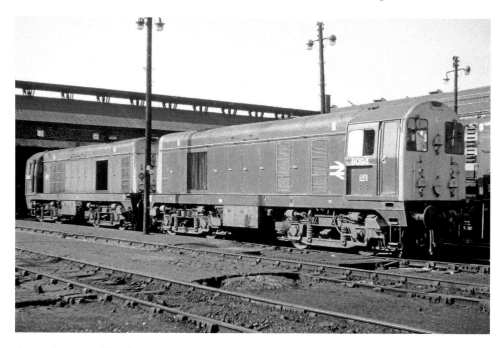

Contrasting sizes of InterCity arrows are applied to this pair of tablet-recess-fitted Class 20s, led by No. 8094 at Polamdie in September 1971. (Arthur Wilson)

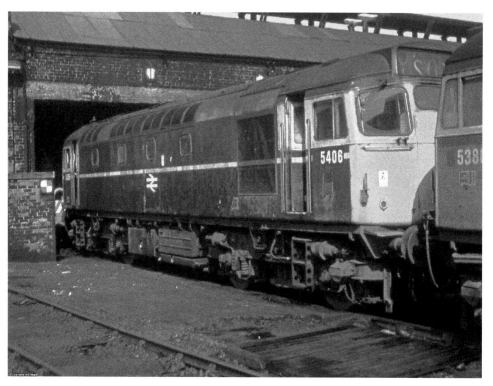

Although it is still green, No. 5406 has recieved a set of arrows as well. Alongside is a fellow Class 27 in two-tone green livery in August 1971 in the summer sushine at Polamdie. (Grahame Wareham)

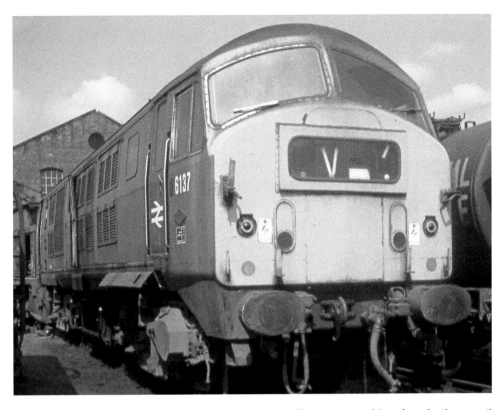

A front-end study of No. 6137 at Polmadie in August 1971; the Class 29 remained here from April 1971 until May 1972 before making its journey to Glasgow Works for cutting. (Grahame Wareham)

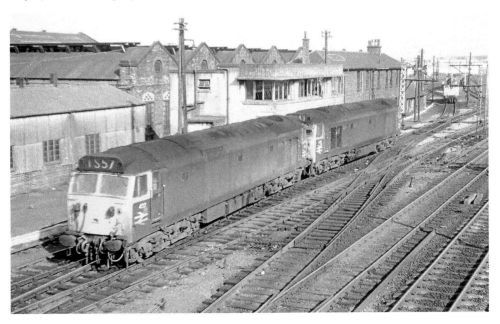

During the period of doubleheaded Class 50s on the WCML, this duo of Nos 432 and 435 stand alongside Polmadie on 21 August 1971. (Arthur Wilson)

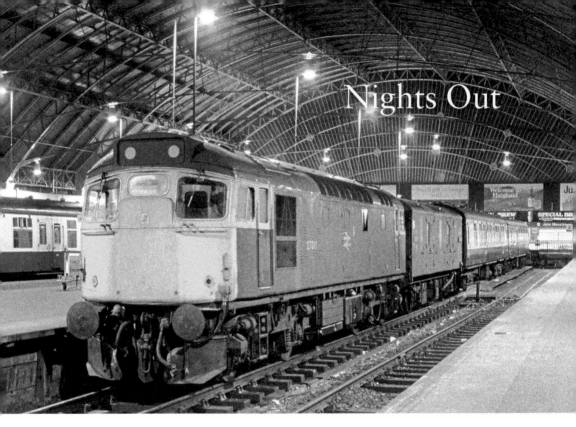

Nights Out

For those heading back from a night out in Glasgow, they could catch the 01.00 Queen Street–Oban service, headed by No. 27011 on Friday 12 October 1979. (Colin Whitbread)

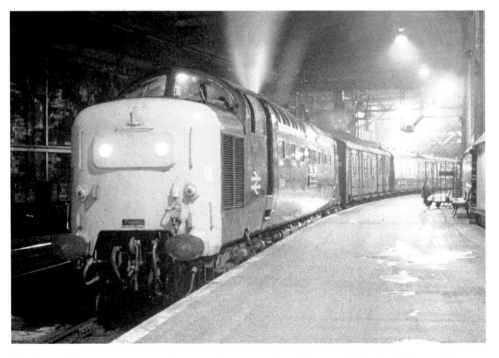

The Napier Deltic exhausts are sent skywards in August 1979 from No. 55014 *The Duke of Wellington's Regiment* at Edinburgh Waverley. (Strathwood Library Collection)

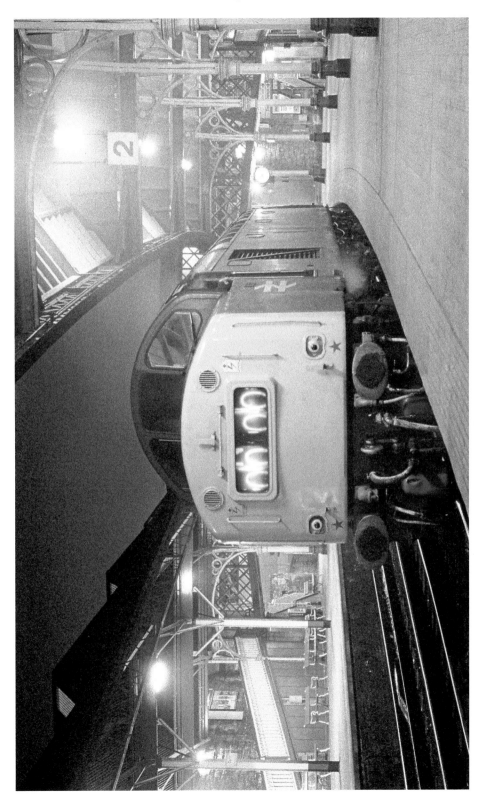

Wisps from No. 40173 catch the cool air at Perth on 22 April 1978. (Nev Sloper)

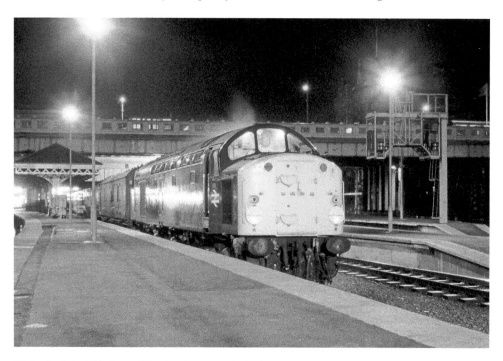

Mail is loaded at Edinburgh Waverley for carriage behind No. 40120 on 19 October 1978. (Nev Sloper)

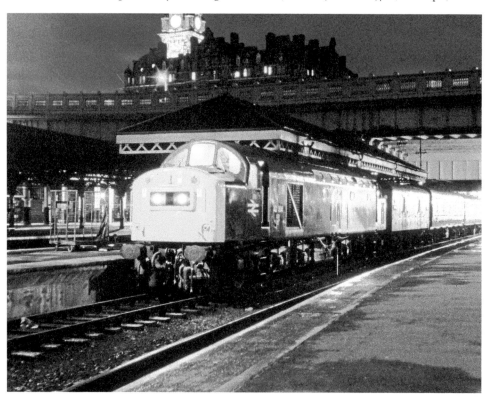

Earlier the same night Waverley was host to No. 40164 during its brief stop. (Nev Sloper)

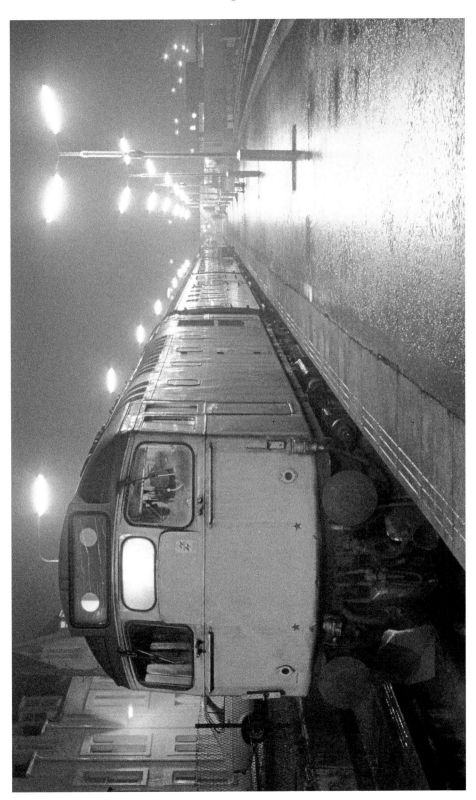

Rain has fallen on 20 December 1979 as No. 27003 waits to start the 18.20 Fort William to Glasgow and Euston service. (Colin Whitbread)

Ramble South West

A friendly passenger engages the driver of No. 40058 in conversation on 12 July 1975 while his engine stands light at the platforms at Carstairs. (Phil Bidwell)

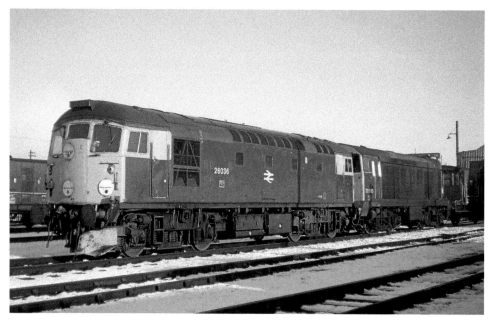

A dusting of snow in January 1979 surrounds Nos 26036 and 20020 in the shed yard at Carstairs; the Class 26 seems to be only partly snow plough fitted, strangely. Carstairs shed closed in September 1963, but re-opened in December 1966 as 66E, only to be downgraded to a stabling point for diesel as of March 1967. (Strathwood Library Collection)

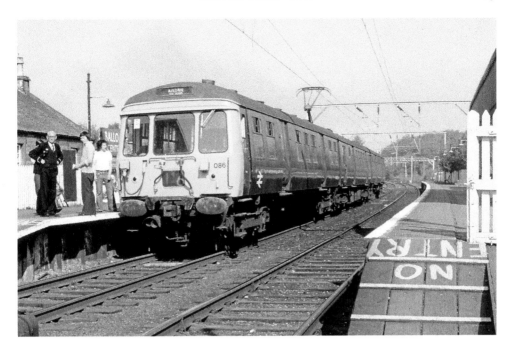

The Blue Trains linked the foot of Loch Lomond at Balloch Pier station with Glasgow Central; here o86 pauses at Balloch during September 1976 on the former Caledonian and North British joint route. (Arthur Wilson)

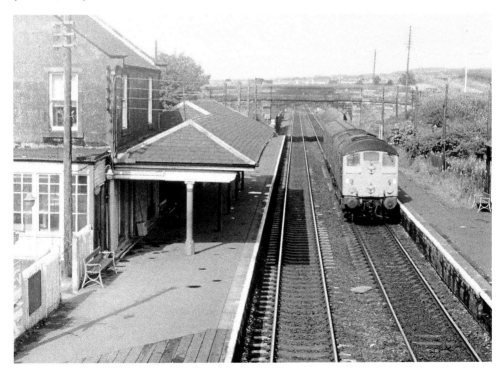

Into Glasgow & South Western Railway territory to Glengarnock on 14 July 1975 as No. 24073 brings a single van into the station. (Phil Bidwell)

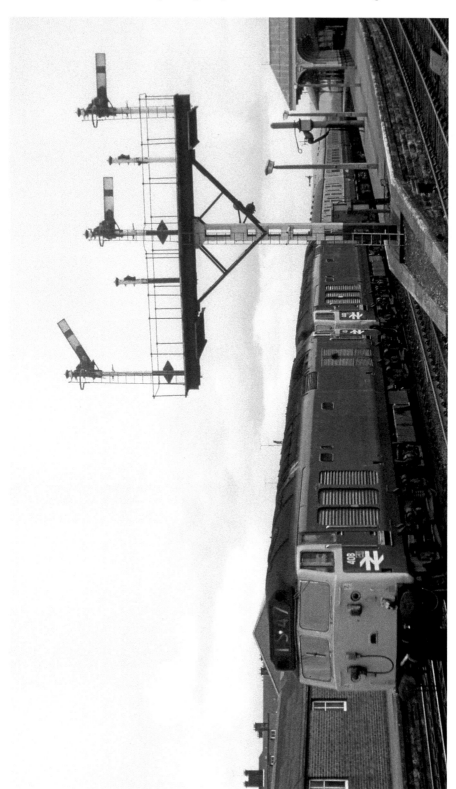

A doubleheaded Class 50 pairing of Nos 408 and 440 rumble through Kilmarnock in April 1973; the latter would be the first to head off to the Western Region in 1974. Meanwhile, renumbered as No. 50008, the leading locomotive would be transferred to Bath Road first and then Laira in 1976. (Arthur Wilson)

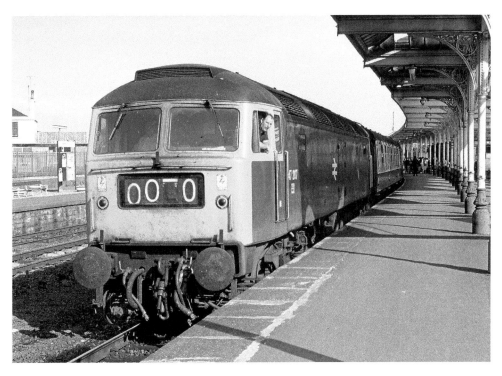

Halted at the start of the long hot summer of 1976 in June was No. 47207, working the 15.40 Carlisle–Glasgow Central service at Kilmarnock. (Arthur Wilson)

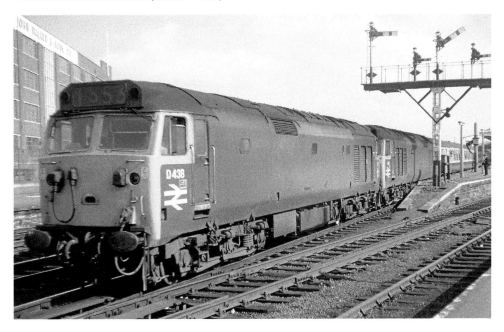

On 11 August 1971 D438 and 410 bring a diverted Euston–Glasgow express through Kilmarnock, where the former Glasgow & South Western Railway established its locomotive works. which closed in 1959. The town is also famous as the home of Johnnie Walker, although part of the Diageo group closure was notified in 2009, making it set to follow the path of Massey-Ferguson, who closed their tractor factory in 1979. (Arthur Wilson)

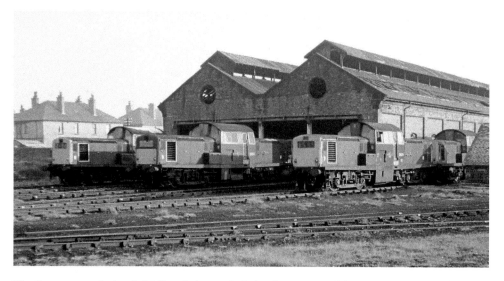

The former steam shed coded 67D at Ardrossan had closed to steam in February 1965 and then to diesel in September 1969, leaving locomotives to be stabled at the harbour here. However the shed made a convenient place to send redundant Claytons in 1971 and 1972 while arrangements were being made for their disposal. This line up shows Nos 8531, 8515, 8573 and 8605 in early 1972. (Arthur Wilson)

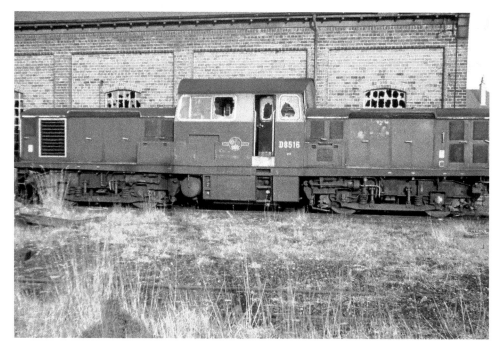

The author recalls that the previously mentioned Dalescroft Railfans coach tours to Scotland over Easter 1972 all seemed to arrive at Ardrossan within a short time of each other; thus it was that over 100 trainspotters, several armed with basic tools, descended upon the rows of withdrawn Claytons intent on souvenirs. Indeed several practice attempts had been made within Glasgow Works earlier that morning. Although a number of the locomotives had already been attacked by local vandals, including D8516, by the time everyone had embarked on the waiting coaches many of the locomotive headcode blinds and builder's plates had been liberated. (Arthur Wilson)

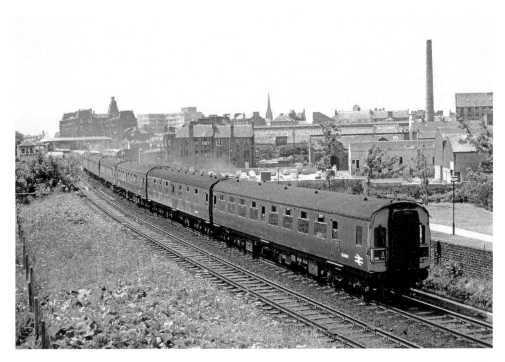

Having been deposed from the Edinburgh–Glasgow route by the Class 27s, the Swindon-built Inter City DMU sets found further employment on trains along the route from Glasgow Central to Stranraer. One such train makes a smoky departure from Ayr in July 1977. (Arthur Wilson)

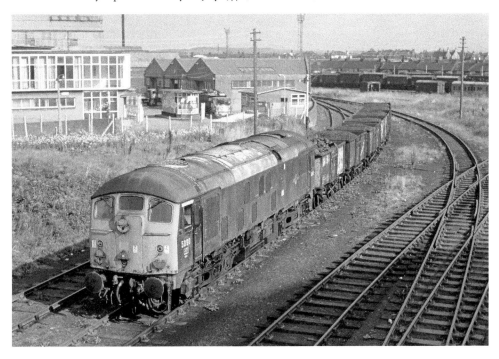

Rounding the curve at Newton-on-Ayr was No. 5090, still in green livery in October 1972 with a short transfer goods. (Arthur Wilson)

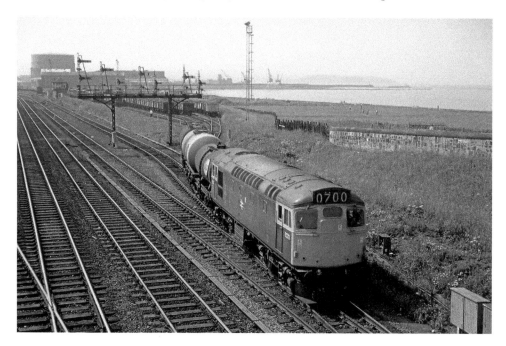

Engaged in a little light shunting at Falkland Yard in August 1972 was No. 5373, an Eastfield-allocated Class 27. (Arthur Wilson)

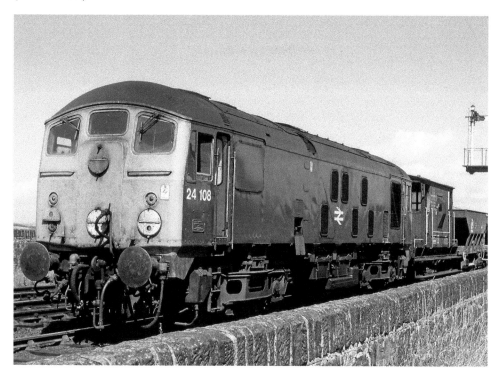

Seen from a position almost trackside at Falkland Yard was No. 24108 in July 1975, just weeks before it was stored firstly at Millerhill. It then went to Haymarket and finally Carlisle, before heading to Doncaster for disposal over Christmas 1977. (Arthur Wilson)

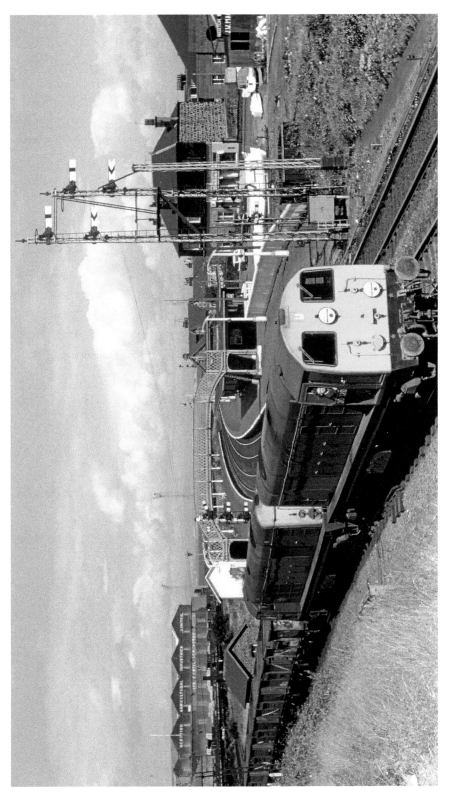

A Class 20 pairing led by No. 20120 brings a coal train around the curves, avoiding Newton-on-Ayr station in August 1974. Passing away the same month was the famous American aviator Charles Lindbergh, who flew his aeroplane the *Spirit of St. Louis* in 1927 solo from New York to Paris in the first non-stop crossing between the two cities, in a time of just over thirty-three hours. (Arthur Wilson)

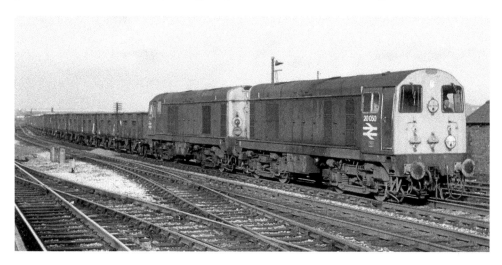

The first built Class 20 D8000, now in the guise of No. 20050, leads another on a coal working within the Ayrshire coalfield from Falkland Junction in February 1975. (Arthur Wilson)

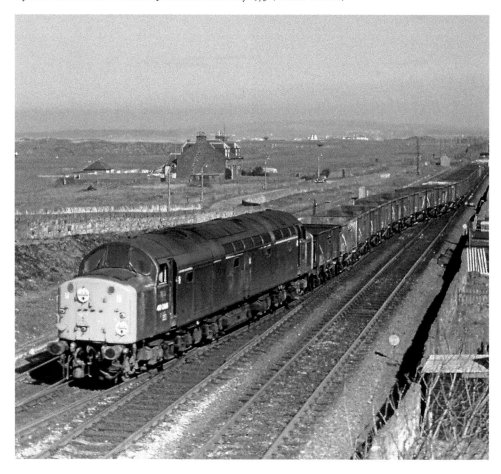

A work-weary green No. 40096 from Kingmoor brings a rake of empties into Falkland Yard in early 1974. (Arthur Wilson)

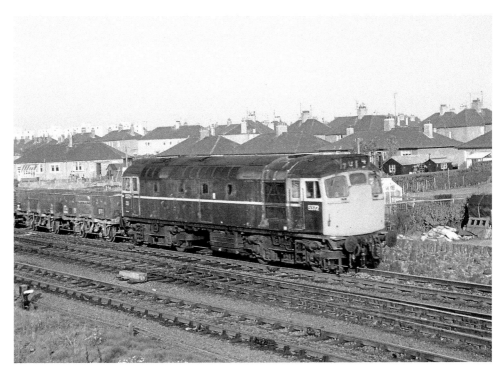

This Class 27 is also still running in green but no crests seem to be present on the flank of No. 5372 in October 1972 near Prestwick. (Arthur Wilson)

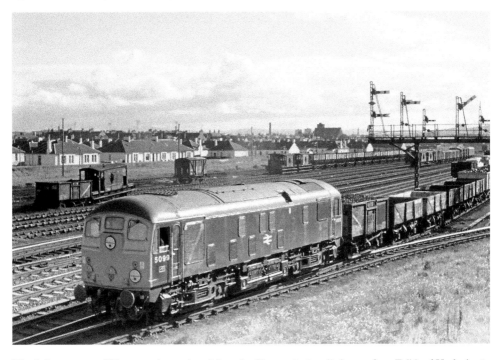

The Sulzer engine of No. 5099 clatters into life as the Class 24 is signalled away from Falkland Yard, also in October 1972. (Arthur Wilson)

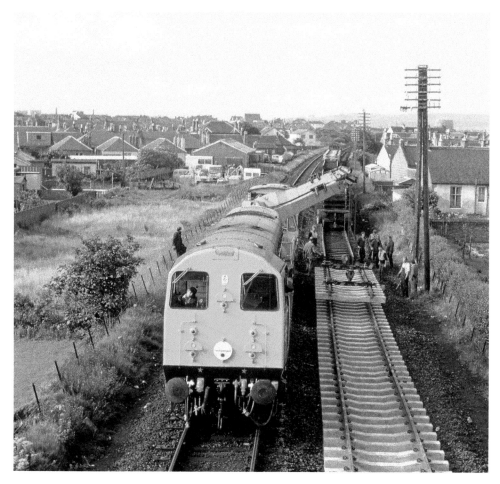

Getting a little extra work in one Sunday in August 1975 was No. 20036, engaged in track relaying near Prestwick. (Arthur Wilson)

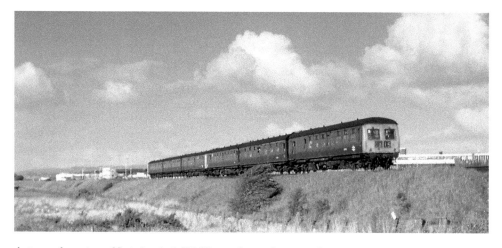

A six-car formation of Swindon-built DMUs are glimpsed as we make our way southwards near Girvan in October 1974. (Arthur Wilson)

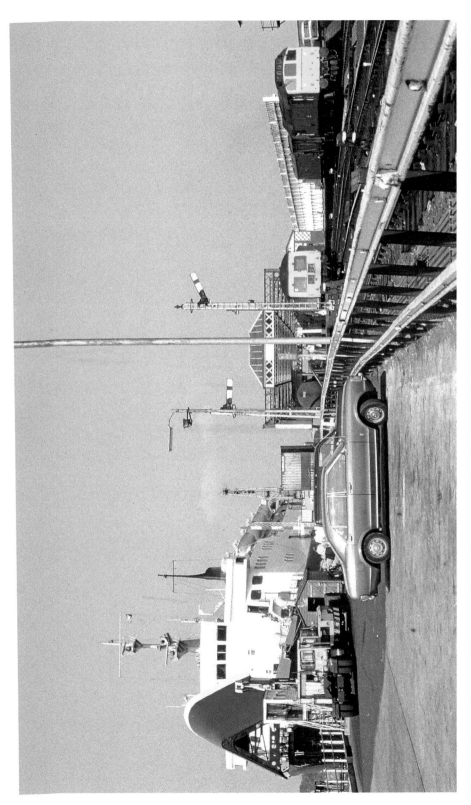

One last look along the jetty at Stranraer Harbour in August 1976, with another DMU and a Class 25 in the station, while a Ford Consul, the cheaper version of the Granada used in *The Sweeney*, is parked up on the quayside. (Arthur Wilson)